IMAGES
of America

# LABOR IN DETROIT

## WORKING IN THE MOTOR CITY

IMAGES
*of America*

# LABOR IN DETROIT

## WORKING IN THE MOTOR CITY

Mike Smith and Thomas Featherstone

ARCADIA
PUBLISHING

Published by Arcadia Publishing
Charleston SC, Chicago IL, Portsmouth NH, San Francisco CA

Printed in the United States of America

Library of Congress Catalog Card Number: 2001091564

For all general information contact Arcadia Publishing at:
Telephone 843-853-2070
Fax 843-853-0044
E-mail sales@arcadiapublishing.com
For customer service and orders:
Toll-Free 1-888-313-2665

Visit us on the Internet at www.arcadiapublishing.com

*This book is dedicated to the people of Detroit who have built and continue to build the Motor City, as well as to the men and women of organized labor whose struggles have improved the lives of all Detroiters.*

# CONTENTS

# ACKNOWLEDGMENTS

The authors gratefully acknowledge the support and assistance of their colleagues at the Walter P. Reuther Library and its director, Dr. Frederick Stielow. Special thanks are extended to Camille Craycraft and Daniel Golodner for their help with the production of this book. We would also like to thank Dave Poremba, manager of the Burton Historical Collection at the Detroit Public Library, for his assistance with photographs and knowledge of that collection. Although we consulted a number of sources for this book, one deserves special recognition: *Working Detroit* by Steve Babson.

Unless otherwise noted, the photographs in this book are from the collections of the Archives of Labor and Urban Affairs at the Walter P. Reuther Library, Wayne State University, Detroit, Michigan. This collection of nearly two million historical photographs represents the work of hundreds of union members and photographers.

# INTRODUCTION

For most of the 20th century, Detroit was America's "Union Town." Historic strikes were staged in metropolitan Detroit; landmark contracts were negotiated with metropolitan employers; and Detroit-based labor leaders rose to become famous thinkers, innovators, and statesmen. Moreover, the city's labor movement has had the power to influence national urban and social policy. In this respect, the most powerful and influential industrial union in American history, the United Automobile Workers of America (UAW), is headquartered in the Motor City.

The impact of the labor movement upon the development of modern Detroit has been profound. Indeed, the effect is woven into the daily lives of its people. Thousands of Detroiters are union members; thousands more are retired from union jobs. Detroit's unions still wield considerable power in the workplace, as well as political clout in local, state, and federal elections. And every day in the city's northern suburbs, thousands of commuters transverse a metropolitan expressway named after a labor leader—Walter Reuther.

Since its founding in 1701, Detroit has been a haven for the working class. Millions of immigrants from around the world and migrants from other parts of the United States made Detroit a point of destination. They came to Detroit to find work, make a new life for themselves, and build a city. The village on the narrows of the Detroit River was the fur trading capital of the Great Lakes during its first hundred years, as well as a home for soldiers, farmers, fur traders, and voyageurs. Over the next two centuries, Detroit grew from a frontier outpost into an industrial powerhouse. Since 1914 it has been the world's undisputed Motor City. Indeed, for most of the 20th century it was a place where hundreds of thousands of well-paid, unskilled jobs were available in the automotive industry.

Although organized labor has existed in Detroit for over 150 years, the city was generally considered an "open shop" town until the 1930s. A few craft unions such as the Iron Molders and Brotherhood of Locomotive Engineers were organized in Detroit during the mid-19th century, but until the Great Depression, the city's labor movement had low membership and limited strength. The Depression with its widespread unemployment and poverty was particularly tough on the city's industrial workers. At its depths over half of Detroit's workforce was unemployed. However, it created an economic environment that was ripe for union organization.

Detroit earned its first world recognition as a stronghold for the labor movement in 1937. Following the example of the Great Sit-down in Flint that ended in February of that year,

a wave of over one hundred local sit-down strikes occurred in the Motor City. Workers at bakeries, dime stores, automobile assembly plants, hotels, cigar factories, and many other places sat-down on the job and refused to work or leave until their demands were met. Journalists from around the world reported the story and the nation watched labor's campaign in Detroit.

Many Americans thought a radical political revolution was brewing in the Motor City. Businessmen loathed the idea of employees banding together to challenge their decisions, but for people who had long suffered the results of economic downturns and total managerial control, the labor movement offered strength in numbers and shared bargaining goals. Although a revolution did not occur, by the end of 1937 Detroit was no longer considered an "open shop" town. The UAW alone gained 250,000 members of which 200,000 were based in metropolitan Detroit.

There was still much to be done to build the labor movement in the Motor City, but from 1941 to 1945, working Detroiters focused upon victory in World War II. Many men and women, black and white, joined the armed forces. Those who stayed in the factories and businesses did their jobs so well that about 25 percent of Allied war material—tanks, bombers, aircraft engines, artillery shells, machine guns, and many other products needed to wage war—was manufactured in Detroit.

The labor movement returned to the task of building the city's unions after the war. Over the next three decades, unions in Detroit bargained for pensions, health care, vacations, safer workplaces, and many other benefits to improve their member's standard of living. Unions worked to eliminate racial and gender discrimination from the workplace, and many union members were in the forefront of the civil rights movement, both in the city and at the national level. Jimmy Hoffa and Walter Reuther, while quite different in philosophy and methods, became two of the labor movement's most visible and influential leaders. Moreover, beyond the automobile industry and the UAW, there was a massive growth in public employee unions for teachers, librarians, and many other city, state, and federal workers.

Since the mid-1970s, however, the labor movement in America has lost a great number of members, resulting in a decline in political and economic power. The 1980s were particularly devastating for labor in Detroit. Computers and robotics revolutionized the nature of manufacturing, dramatically increasing quality and efficiency, but at the cost of thousands of union jobs in metropolitan Detroit.

The Motor City, however, is still a union town. At the turn of the 21st century, over 40 unions have locals in Detroit, with over 350,000 members. While the city grapples with the effects of the global economy, however, unions are re-thinking their needs, goals, and relationships with employers.

Detroit has transformed itself several times over its 300-year history. It has evolved from a fur trading outpost into a commercial center on the Great Lakes, to one of America's great industrial cities, and finally to the World's undisputed Motor City. And for over 150 years, whether small or large, weak or strong, the labor movement has helped shape the modern city. If history does repeat itself, then over the next 100 years, Detroit's unions and their members will help build the Motor City throughout the 21st century.

# One

# BEFORE THE
# AUTOMOBILE

# 1701–1896

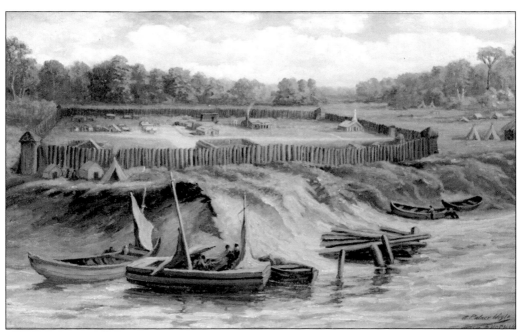

A PAINTING OF FORT PONTCHARTRAIN, C. 1701. One might say that Detroit began as a place for the working class. On July 24, 1701, Antoine de la Mothe Cadillac and his band of about fifty soldiers and fifty settlers landed on the banks of the Detroit River and built Fort Pontchartrain. For the next one hundred years, the village of Detroit was the fur trading capital of North America. (Courtesy of the Burton Historical Collection, Detroit Public Library.)

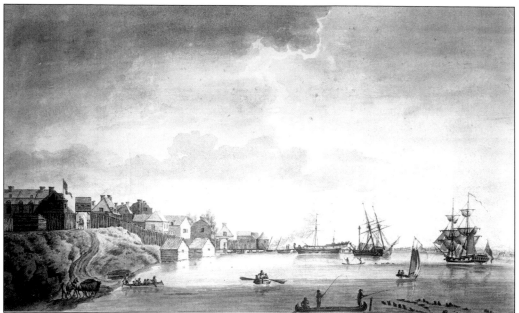

**A PAINTING OF DETROIT, 1794**. This painting depicts Detroit two years before the British transferred command of the outpost to the United States. At this time, it was a small fortified village of about 1,000 people, which burned to the ground in 1805. The city rebuilt itself and with the opening of the Erie Canal in 1825 it and the Michigan territory began to grow. (Courtesy of the Burton Historical Collection, Detroit Public Library.)

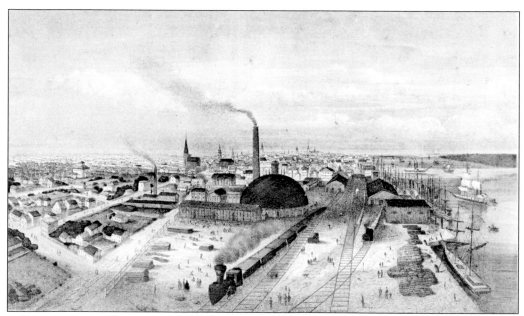

**A RENDERING OF DETROIT, C. 1860**. By 1860 Detroit was the 19th largest city in the United States and the most important commercial center on the Great Lakes. It was also a point of destination for immigrants from Ireland, Germany, Canada, and Great Britain, as well as for migrants from New York, New England, and other parts of America, all seeking work and a chance for a new life. (Courtesy of the Burton Historical Collection, Detroit Public Library.)

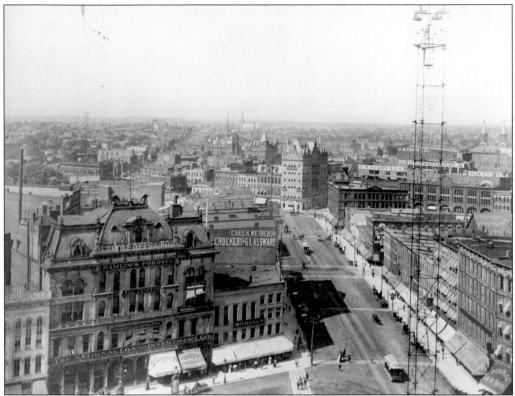

DETROIT, C. 1890. By 1890 Detroit was the 14th largest city in the United States and the nation's largest producer of railroad cars and ships, as well as the world's largest producer of cast-iron stoves, among many other goods. This meant that there were plenty of industrial jobs for skilled and unskilled workers and thousands of migrants made their way to Detroit each year to find work in the city's factories. (Courtesy of the Burton Historical Collection, Detroit Public Library.)

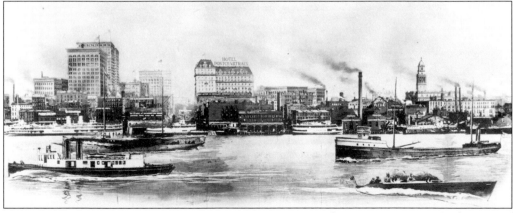

THE DETROIT WATERFRONT AS VIEWED FROM WINDSOR, CANADA, C. 1896. At the turn of the 20th century Detroit was a city of 285,000 citizens, of which over one-third were born in foreign lands. It was a city poised to become the capital of the automotive world. At this time, despite the presence of some labor unions, Detroit was still considered an "open shop" town. (Courtesy of the Burton Historical Collection, Detroit Public Library.)

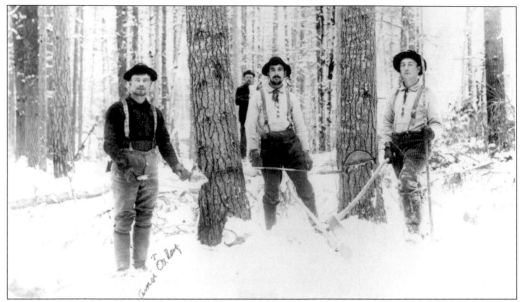

**LUMBERJACKS IN NORTHERN MICHIGAN, C. 1890.** From the 1860s until the 1890s Michigan led the nation in lumber production. This industry generated millions of dollars for many entrepreneurs in Michigan, many of whom lived in Detroit and invested their profits in the city's new industrial concerns. In this respect the lumber industry fueled much of the city's development.

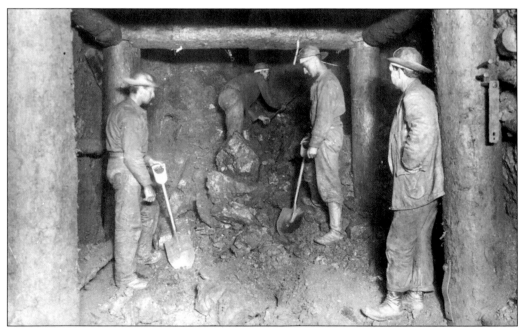

**MINERS IN MICHIGAN'S UPPER PENINSULA, C. 1880S.** Along with Michigan's lumber industry, iron and copper mining, which began in the state's upper peninsula in the 1840s, created wealth for Detroit entrepreneurs and provided necessary raw materials for the city's industries. Once the Soo Locks opened in 1855 in Sault St. Marie, Michigan, thereby linking Lake Superior with Lake Huron, the cost of shipping raw materials to Detroit was drastically reduced. (Courtesy of the State of Michigan Archives.)

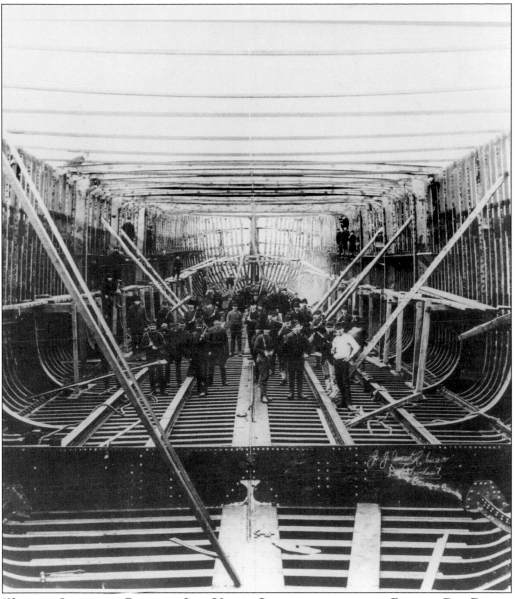

**WORKERS INSIDE THE RIBS OF A SHIP UNDER CONSTRUCTION AT THE DETROIT DRY DOCKS,** c. **1890.** By the 1860s shipmakers at the Detroit Dry Docks had formed one of the city's early unions, a local of the national Ship Carpenters and Caulkers union. Michigan's first national labor leader, Richard Trevellick, was president of this local in 1862. (Courtesy of the Burton Historical Collection, Detroit Public Library.)

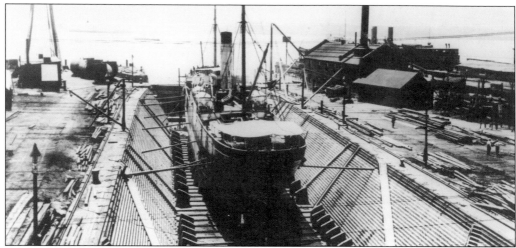

DETROIT DRY DOCKS, C. 1890. Founded in 1852 by Oliver Newberry, the Detroit Dry Dock Company owned dry docks in Detroit and Wyandotte, Michigan, and was the one of the largest producers of ships in the nation. In 1890 over 600 workers, skilled carpenters, caulkers, mechanics, and laborers worked for the company. (Courtesy of the Burton Historical Collection, Detroit Public Library.)

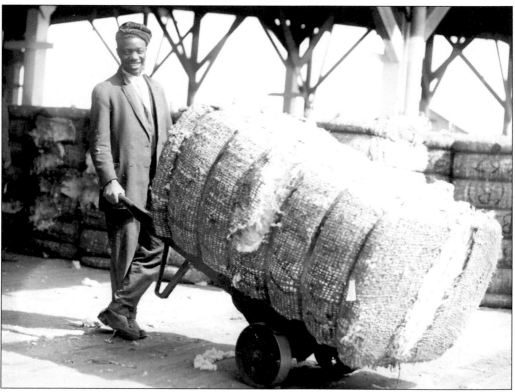

AFRICAN-AMERICAN STEVEDORE, C. 1905. Throughout the 19th century and well into the next century, African Americans were on the lowest rung of the employment ladder. In general, until the post-World War II era only a few positions, such as laborer, domestic, barber, or stevedore, were open to blacks in Detroit.

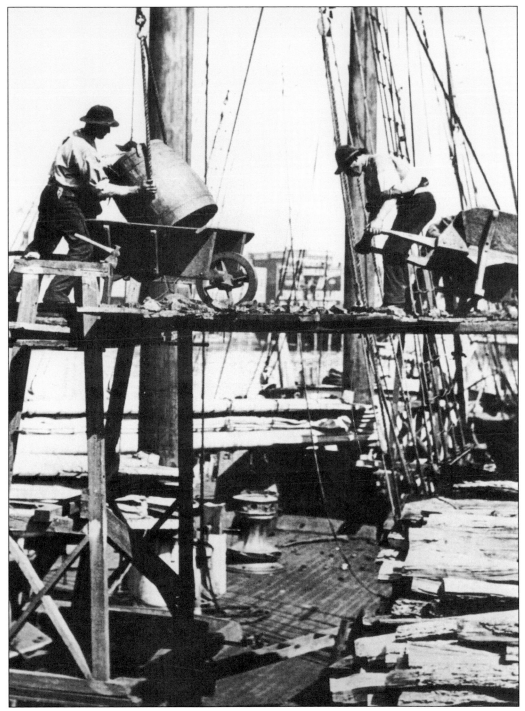

STEVEDORES UNLOADING SHIPS AT THE PORT OF DETROIT, C. 1890. For much of the 19th century, unskilled workers could find work loading and unloading ships at Detroit's busy docks. Such "day laborers" were often African Americans, Irish immigrants, or from other groups that were usually the "last hired and first fired" by American and Detroit employers. (Courtesy of the Burton Historical Collection, Detroit Public Library.)

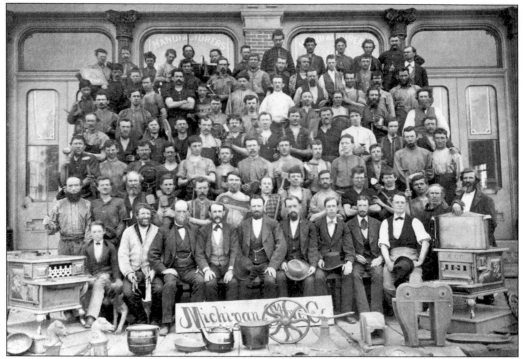

THE ENTIRE WORKFORCE OF THE MICHIGAN STOVE COMPANY, 1872. By 1890 the Michigan Stove Company—one of several large stove manufacturers in Detroit—employed over 1,200 workers. Another company, the Detroit Stove Works, had the largest stove factory in the world. Detroit's stove industry was also a stronghold for the Iron Molders union. (Courtesy of the Burton Historical Collection, Detroit Public Library.)

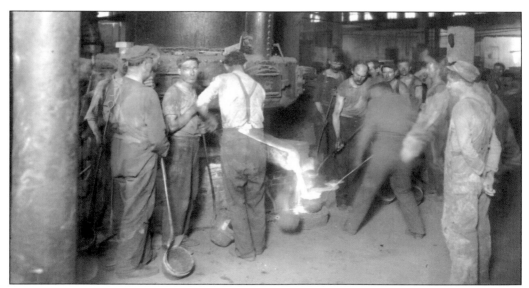

IRON MOLDERS AT WORK IN A DETROIT FACTORY, C. 1890. Iron molding was hot, dirty, and dangerous work. Pictured here are skilled "puddlers" who transfer liquid iron fresh from the furnace into various molds that shaped the molten iron into finished products or parts. As early as the 1850s iron molders organized themselves into labor unions.

**RAILROAD CAR OUTSIDE AN AMERICAN CAR AND FOUNDRY PLANT IN DETROIT, 1899.** In the 1890s Detroit's railroad car manufacturers, iron foundries, and forges combined to produce more railroad cars or "rolling stock" than any other American city. Throughout the decade railroad carmakers were the city's largest employers.

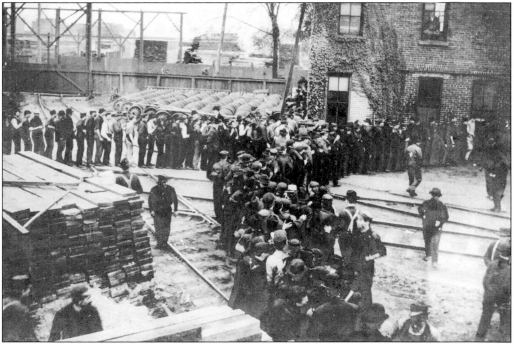

**PAYDAY AT AN AMERICAN CAR AND FOUNDRY PLANT IN DETROIT, 1899.** Detroit, like other major cities in the United States, experienced a wave of immigration that did not subside until after World War I. Many migrants to Detroit found work in the city's many factories; in particular, many found work with railroad car manufacturers.

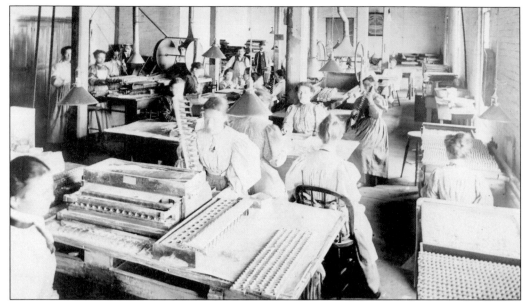

**WOMEN MAKING GELATIN CAPSULES AT PARKE, DAVIS & CO., C. 1890.** Detroit was also home to other important industries, such as pharmaceutical manufacturing. This industry was also the largest employer of women in Detroit during an era when most females could only find work as domestics, teachers, sales clerks, and homemakers.

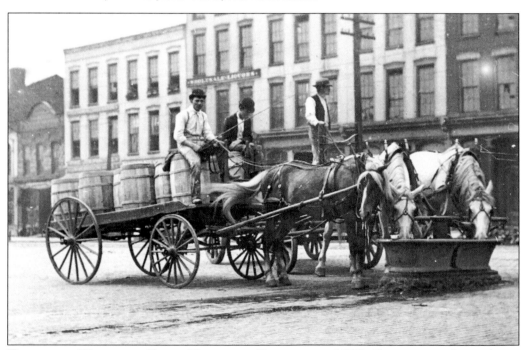

**TEAMSTERS WATERING THEIR HORSES IN DETROIT, C. 1890.** Teamsters, or horse-drawn wagon drivers who delivered goods throughout the city, were essential workers in Detroit. This was tough work, along with driving open wagons regardless of weather, teamsters also had to take care of their horses. The International Brotherhood of Teamsters union was founded in 1903 and Detroit has been one of the union's strongholds since that time.

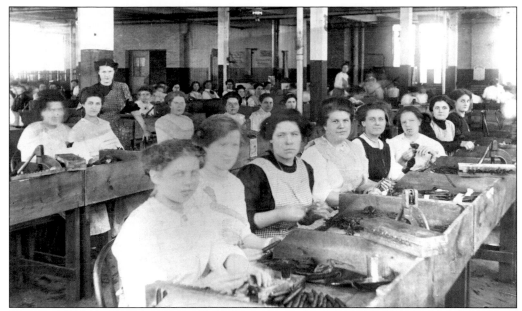

WOMEN MAKING CIGARS AT THE SAN TILMO CIGAR FACTORY, C. 1890. Detroit, the "Tampa of the North" in the 1890s, was the nation's third largest producer of cigars and other tobacco products. This industry employed hundreds of workers, especially young immigrant Polish women. The first national cigar makers' union was formed during the Civil War. (Courtesy of the Burton Historical Collection, Detroit Public Library.)

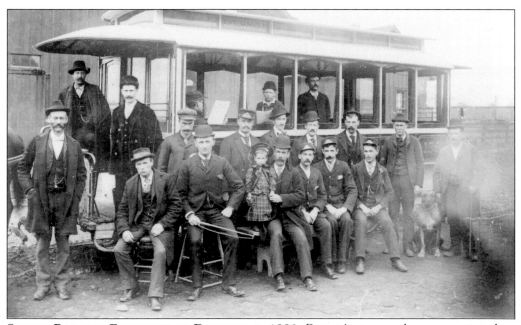

STREET RAILWAY EMPLOYEES IN DETROIT, C. 1890. Detroit's street railways constituted an essential public service by the 1890s. Thousands relied upon them to get to work everyday. The Amalgamated Association of Street Railway Employees held a major successful strike over wages, work hours, and seniority in Detroit in 1891, virtually shutting down the city. In this case they had the support of many citizens and business leaders.

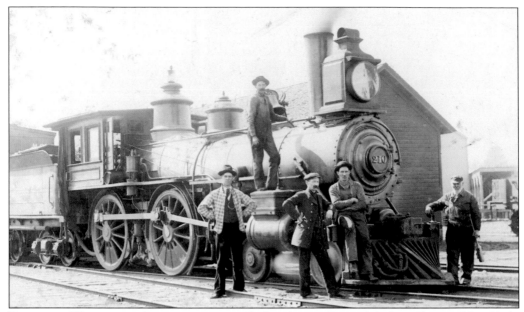

RAILROAD WORKERS IN DETROIT, C. 1870. Railroads were Detroit's link to Chicago, New York, Toronto, and other major American and Canadian cities. Railroad workers were among the first in America to organize themselves into trade unions. The forerunner of the Brotherhood of Locomotive Engineers, the Brotherhood of the Footboard, was founded in Detroit in 1863 when 13 engineers from the Michigan Central Railroad issued a convention call.

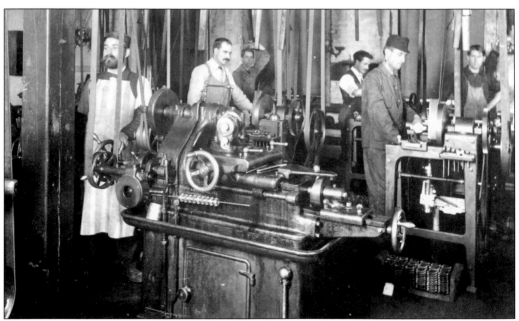

MACHINISTS AT THE LELAND & FAULCONER FACTORY IN DETROIT, 1890s. By the 1890s Detroit was home to hundreds of machine shops run by highly skilled machinists and mechanics; in particular, German immigrants were important in creating this industry. These shops formed one of the essential elements for Detroit's transition into the Motor City. The first machinist and blacksmith union was formed in Philadelphia in 1857.

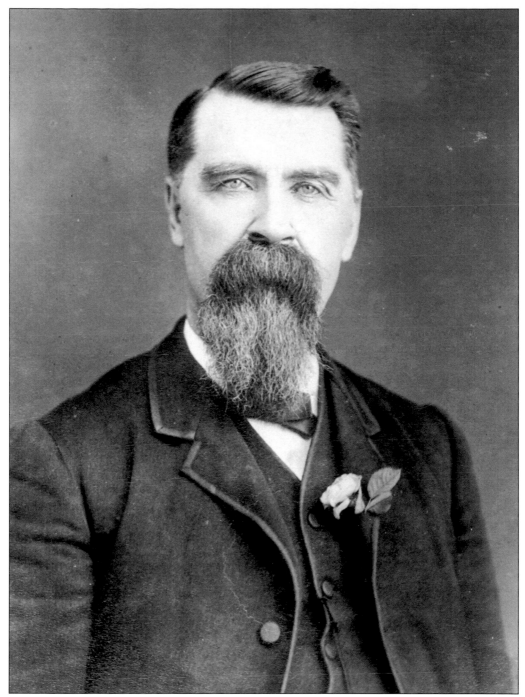

**RICHARD TREVELLICK, UNDATED.** Richard Trevellick was the first national labor leader from Detroit. Born in England, he came to Detroit in 1862 and began work at the Detroit Dry Docks. Two years later Trevellick became the first president of the short-lived Detroit Trades Assembly. He soon became a prominent activist for the eight-hour day and a founder and president of the National Labor Union, a forerunner of the American Federation of Labor. (Courtesy of the Labadie Collection, The University of Michigan.)

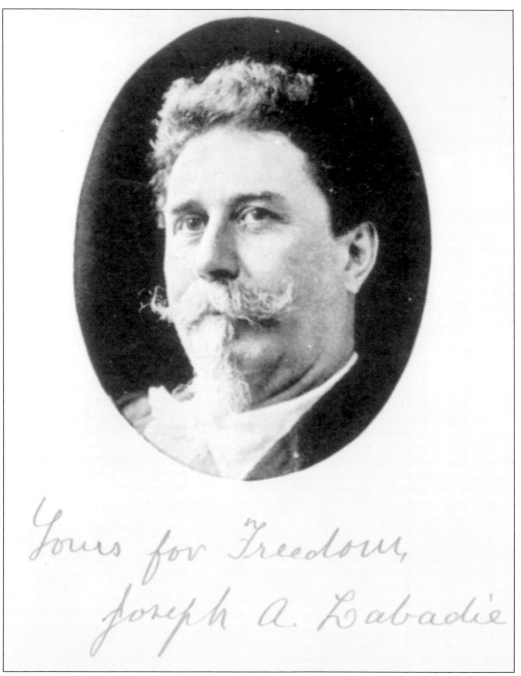

**JOSEPH A. LABADIE, UNDATED.** Joseph Labadie was Detroit's premier labor activist at the turn of the 20th century. In 1878 he organized Michigan's first local Knights of Labor assembly. When that national labor umbrella organization failed by the 1890s, Labadie helped form today's Michigan Federation of Labor and served as its first president. His collection of papers is now a premier labor history archive at the University of Michigan. (Courtesy of the Labadie Collection, The University of Michigan.)

LETTER FROM MALCOLM J. MCLEOD, PRESIDENT OF THE DETROIT TRADES COUNCIL, 1901. This letter was in the Detroit Centennial Box, opened for the Detroit tricentennial. Formed in 1880, the Detroit Trades Council was the forerunner of today's Metropolitan Detroit AFL-CIO. The short-lived Detroit Trades Assembly, formed in 1864, was the city's first central labor body. The Michigan Federation of Labor was established in 1889. (Courtesy of the Detroit Historical Museum.)

**Detroit Street Railway Employes' Association**

No. 26.

**16 TELEGRAPH BLOCK, Cor. Griswold and Congress.**

The working people of the city of detroit, are enjoying better conditions than they have enjoyed for A number of years, Men who labor not mechanics, are Paid one dollar and fifty cents per day for all public work, and nearly all are employed. our shops and factorys are employing thousands of men, labourers in the factorys are paid from 90 cents A day to one dollar and thirty five cents per day, MOulders of iron earn from $2.50 to $3.50 per day Carpenters are paid 25 center per hour masons 50 cents per hour, and all men who are emplyed in the building trades are eqally well paid as those named above, ALL skilled labor in the city of Detroit is organized into trades unions, and through the efforts of those unions men have bettered their conditions, they have reduced the hours of labor, and have increased their wages so that they can now find time to educate them selves and their children and take their place in society which has been denied them.

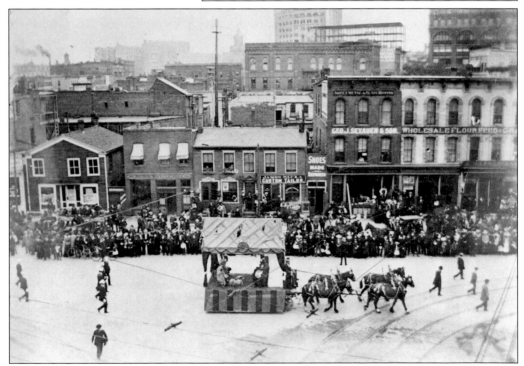

DETROIT LABOR DAY PARADE, 1898. The tradition of a Labor Day parade began in the 1880s when workers marched at night. This was before the official holiday was declared in 1894. In 1886, however, the first daylight parade of about 11,000 people was held. From this time until today, with few exceptions, Detroit unions and workers have held a Labor Day parade.

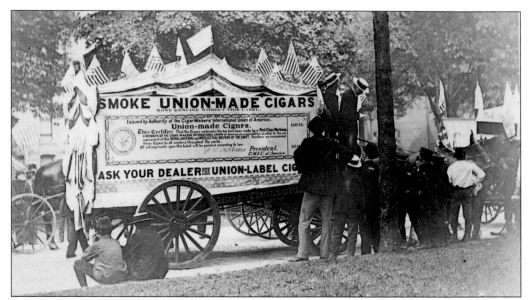

CIGAR MAKERS' FLOAT FOR THE DETROIT LABOR DAY PARADE, 1894. By 1894 cigar making was one of the leading industries in Detroit, and the Cigar Makers International Union was firmly established in the city. The float pictured here also promotes an important aspect of the labor movement: the union labels allow consumers to determine union made products from non-union ones. (Courtesy of the Burton Historical Collection, Detroit Public Library.)

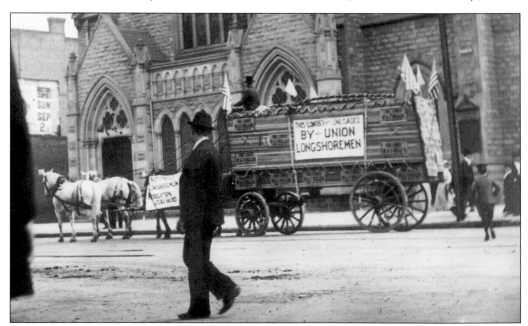

LONGSHOREMEN'S FLOAT FOR THE DETROIT LABOR DAY PARADE, 1894. This float is pictured in front of the United Methodist Church at Adams and Woodward Ave. in downtown Detroit. During this era the Port of Detroit was one of the busiest ports in the nation and it relied upon longshoremen to load and unload ships. The National Longshoremen's Association—forerunner of today's International Longshoremen's Association—was founded in Detroit in 1892. (Courtesy of the Burton Historical Collection, Detroit Public Library.)

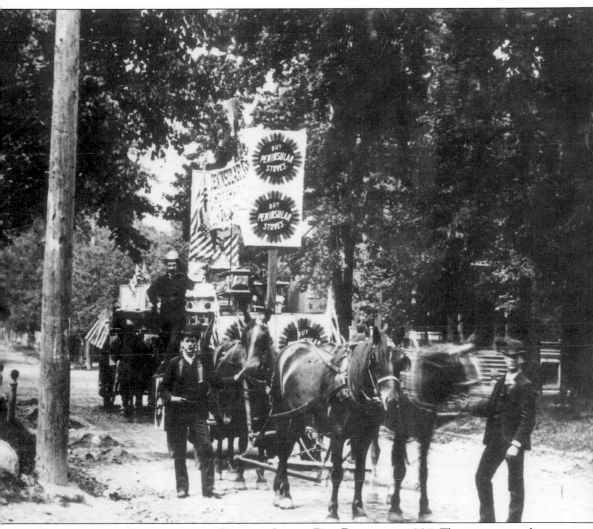

IRON MOLDERS' FLOAT FOR THE DETROIT LABOR DAY PARADE, C. 1890. These union workers are from the Peninsular Stove Company, the third largest stove manufacturer in Detroit behind the Detroit Stove Works and the Michigan Stove Company. In 1890 it employed over 800 workers and made over 40,000 stoves per year. (Courtesy of the Burton Historical Collection, Detroit Public Library.)

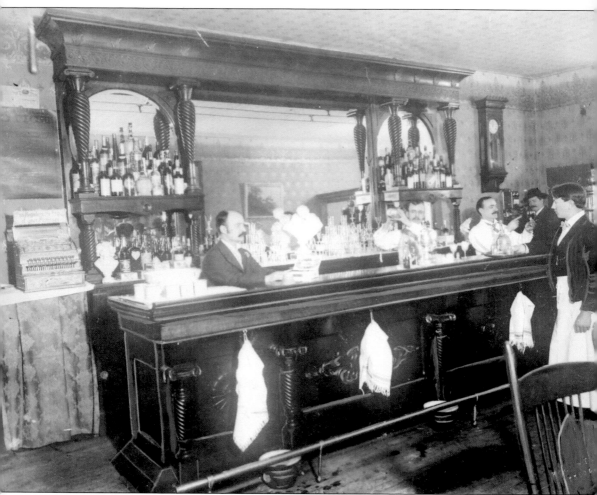

GARIBALDI SALOON AT 20 MONROE AVENUE IN DETROIT, 1898. In the 19th century, saloons were more than just places to drink liquor and beer. For workers, they were places to organize as well as socialize. Union meetings were held in saloons, away from employers who fired anyone who spoke in favor of trade unions. Before public libraries were common, saloons might also maintain a small library for its patrons. (Courtesy of the Burton Historical Collection, Detroit Public Library.)

# Two

# BUILDING THE
# MOTOR CITY

# 1896–1937

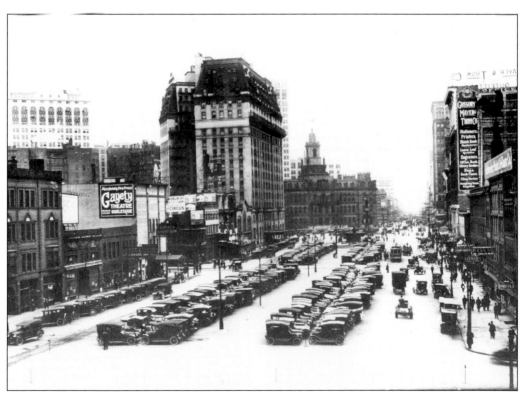

CADILLAC SQUARE IN DOWNTOWN DETROIT, C. 1916. By 1916 Detroit was the automotive production capital of world, the undisputed Motor City. Over half of the world's cars and trucks were built in metropolitan Detroit. This phenomenon also changed the landscape of the city. The automobile soon replaced horse-drawn transportation.

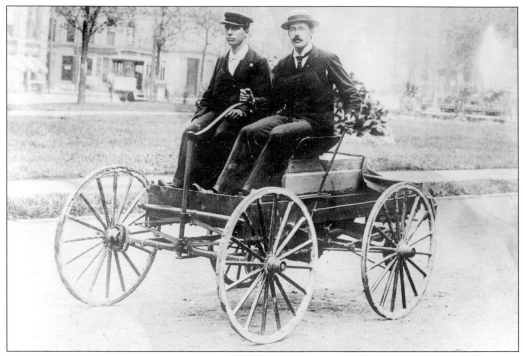

THE FIRST AUTOMOBILE IN DETROIT, 1896. Detroit inventor Charles Brady King (right) and Oliver Barthel, a German immigrant engineer, drove the King Car down Woodward Avenue at 11:00 p.m. on March 11, 1896. This was the first horseless carriage ride in the city and Michigan. Although the car was not a commercial success, both King and Barthel had long careers in the automobile industry.

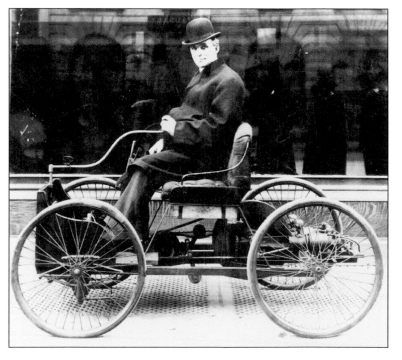

HENRY FORD SITTING IN HIS FAMOUS QUADRICYCLE, UNDATED. In June 1896, three months after Charles Brady King drove the first car in Detroit, Ford drove his first automobile, the "Quadricycle," on Bagely Avenue in Detroit. After his first two automobile companies failed, Ford and his backers founded the Ford Motor Company in 1903. It is now the second largest automotive company in the world.

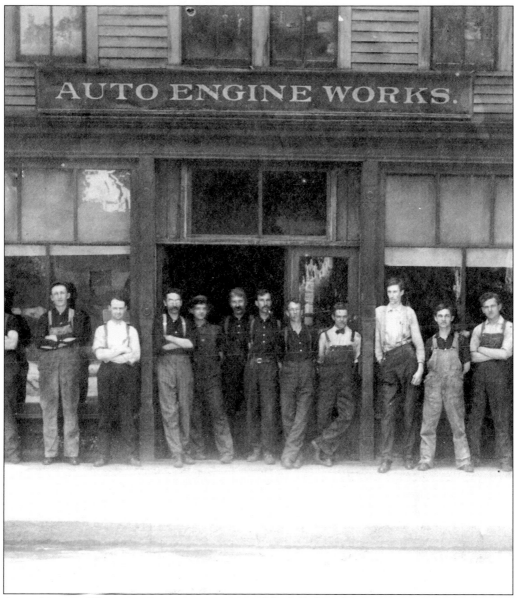

**AUTO ENGINE WORKS IN DETROIT, 1911.** Highly skilled workers operating in small machine shops and factories dominated the early years of the automotive industry in Detroit and the United States at large. Much like the industry today, automotive suppliers such as the Dodge Brothers and the Fisher Brothers produced engines, transmissions, car bodies, and other components automakers used to assemble complete vehicles.

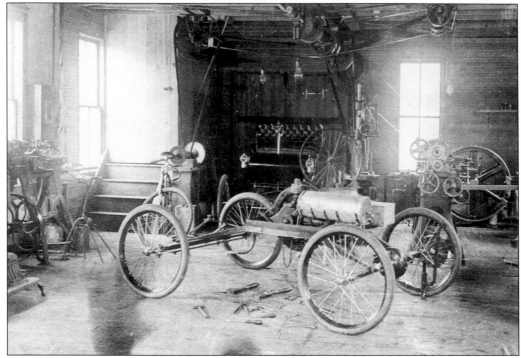

INSIDE OF THE OLDS MOTOR WORKS IN DETROIT, 1900. In 1899 Ransom E. Olds built the Olds Motor Works—the forerunner of General Motor's Oldsmobile division—on River Street, near Belle Isle in Detroit. It was the first factory in the world constructed exclusively to manufacture automobiles. By 1901, relying upon skilled workers to assemble cars and automotive suppliers for parts, Olds produced 425 cars and was America's sales leader.

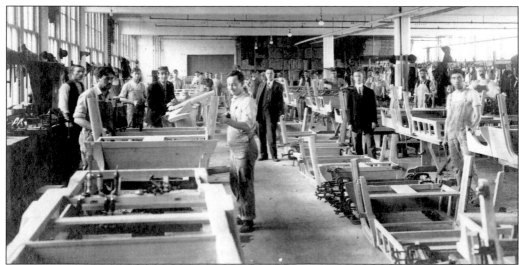

INSIDE OF AN AUTOMOBILE BODY PLANT IN DETROIT, C. 1908. Suppliers, often former carriage makers who adapted their product for cars and trucks, often built early automobile bodies. Before the assembly line, large numbers of skilled carpenters and other tradespeople were needed to make automobiles. In general during this era, about 90 percent of an automotive company's workforce consisted of skilled workers.

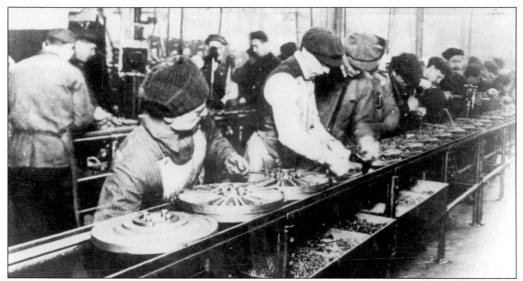

MAGNETO ASSEMBLY LINE AT THE FORD MOTOR COMPANY'S HIGHLAND PARK PLANT IN HIGHLAND PARK, MICHIGAN, C. 1913. Henry Ford first used a moving assembly line for the production of magnetos. By 1914 he had installed moving assembly lines throughout the Highland Park plant and hired unskilled workers to perform simple tasks on the assembly line, thereby increasing efficiency and production speed. This meant work for thousands of people, regardless of education or skill.

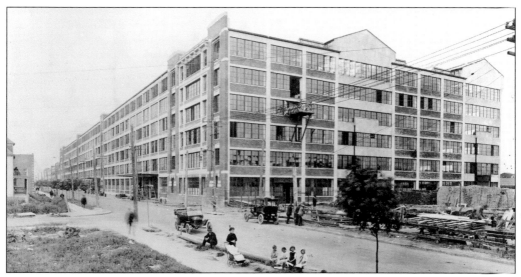

FORD MOTOR COMPANY'S HIGHLAND PARK PLANT, 1918. This plant first opened in 1910 in the village of Highland Park and produced automobiles until the 1950s. It was built to produce Ford's famous Model T, the car that put America on wheels. At its peak capacity in the 1920, over 50,000 people worked in the plant each day—a population larger than that of the village itself. Soon after moving assembly lines were installed in the plant, it produced over 1,000 Model Ts per day. During this era over 50 languages were spoken on the shop floor, including sign language used by deaf workers hired for jobs in the loudest factory departments. Albert Kahn designed the plant using plenty of windows for natural light and improved ventilation, which earned the factory a nickname: the Crystal Palace.

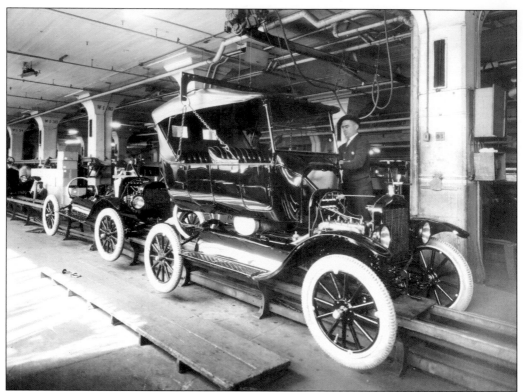

FINAL ASSEMBLY LINE AT THE HIGHLAND PARK PLANT, C. 1918. This picture shows the Body Drop on the final assembly line at Highland Park. At this point during the production process, the car body is added to or "dropped" onto the Model T chassis, thus creating a complete automobile.

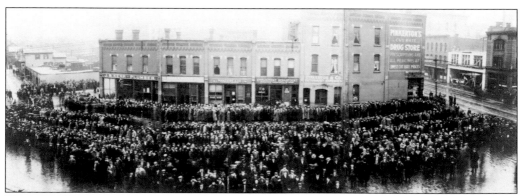

WORKERS OUTSIDE THE EMPLOYMENT OFFICE OF THE EMPLOYERS ASSOCIATION OF DETROIT, 1914. From its founding in 1903 until the 1930s, the Employers Association of Detroit controlled most industrial hiring in the city. This crowd of workers came to Detroit after Ford Motor Company announced the Five Dollar Day, which essentially doubled daily wages for autoworkers. However, single men, women, and African Americans were not eligible for the Five Dollar Day.

32

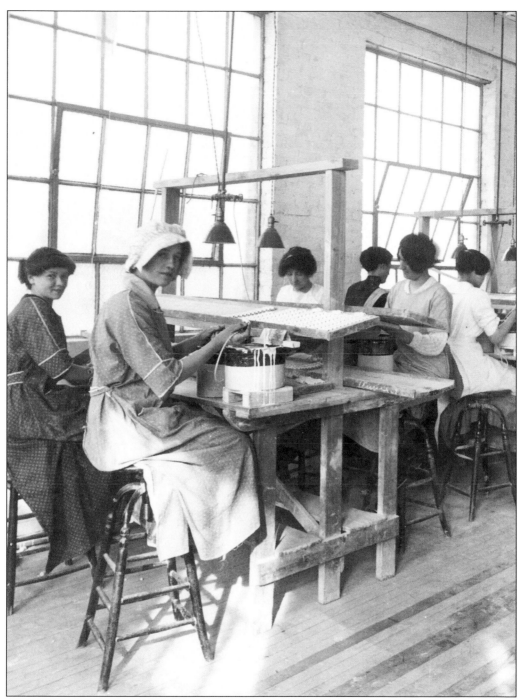

WOMEN MAKING CERAMICS FOR AUTOMOBILE SPARK PLUGS AT THE JEFFREY-DEWITT COMPANY IN DETROIT, 1912. Women did not enter the automobile industrial workforce in large numbers until World War II. Initially, when automotive firms hired them, women were most often employed as secretaries, clerks, and seamstresses, or in production facilities that produced small parts. The reasoning was that small hands were best for small parts or production processes that required great dexterity.

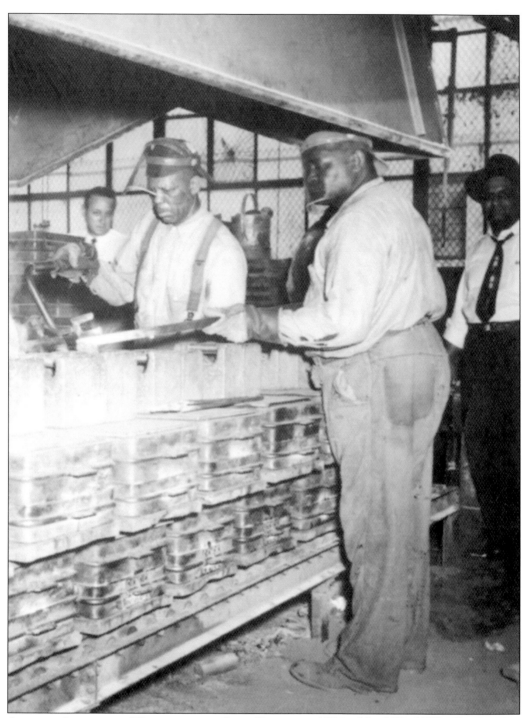

AFRICAN AMERICANS WORKING IN AN IRON FOUNDRY, 1930S. Until World War II only a few Detroit automotive firms such as Ford Motor Company and Midland Steel hired large numbers of African Americans. When hired before the labor movement changed the industry, they were often given the toughest jobs in foundries, steel and iron mills, and assembly plants, and paid less than their white counterparts.

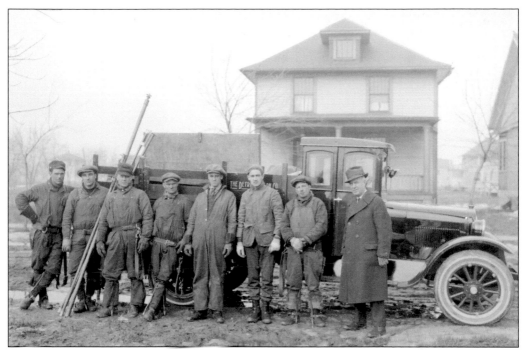

ELECTRICAL LINE GANG FROM THE DETROIT EDISON COMPANY, 1929. Although much of Detroit's workforce was employed in automotive-related work, thousands of other workers helped build the Motor City. Pictured here are the linemen who maintained electrical power in the city. This was highly dangerous work, stringing and repairing electrical wires, often in adverse weather conditions. Detroit's linemen organized themselves into International Brotherhood of Electrical Workers Local 17 in 1891.

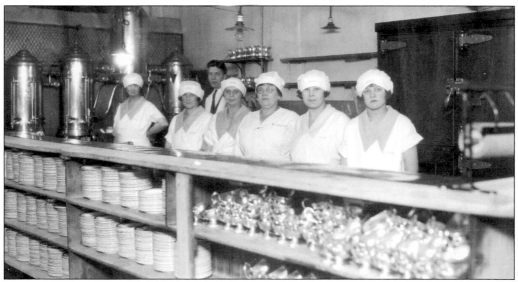

THE KITCHEN STAFF AT THE DETROIT ATHLETIC CLUB, C. 1925. Many women, especially African-American women, found work in Detroit's restaurants, hotels, and clubs. Such work was considered suitable and traditional for women and black workers, and it provided jobs for many newly arrived immigrants.

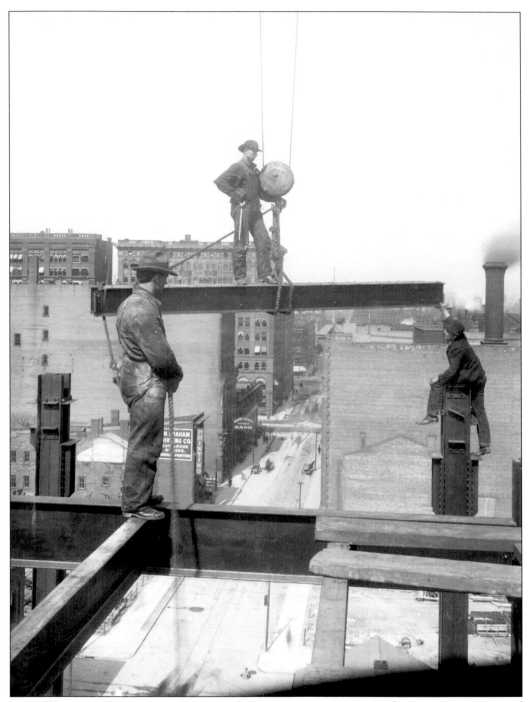

Iron Workers Building a Detroit Skyscraper, c. 1909. As the city grew, more and more skyscrapers were built. Constructing the steel structures for the buildings required brave and skilled iron workers. Native Americans such as the Mohawks who came to Detroit were especially skilled at this work and became known as "sky walkers."

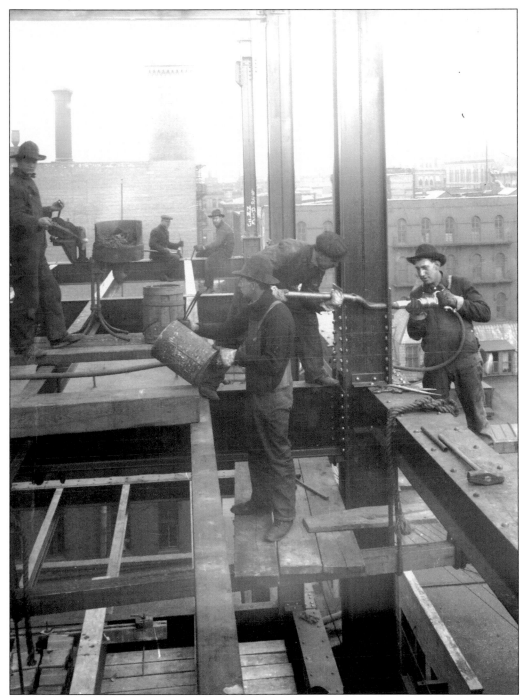

IRON WORKERS BUILDING A DETROIT SKYSCRAPER, C. 1909. Ironwork first developed as a distinct trade in the late-19th century when bridge builders began to replace wood beams with steel beams. Bridge carpenters then transformed themselves into structural steelworkers. The first national union of ironworkers, the International Association of Bridge and Structural Iron Workers, was formed in 1896.

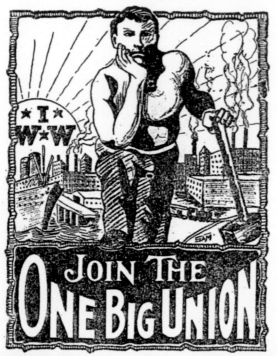

**INDUSTRIAL WORKERS OF THE WORLD RECRUITMENT POSTER, c. 1913.** Formed in 1905, the Industrial Workers of the World— often referred to as the "Wobblies"— believed workers had nothing in common with their employers, and that they should organize themselves into one big union. The IWW also advocated an eight-hour workday, the banning of child labor, and equal rights and pay for men and women regardless of race.

**IWW MEMBERS IN DETROIT, c. 1920.** Pictured here is Big Bill Haywood (third from right), secretary-treasurer of the IWW. In 1913 the IWW led a walkout of the Studebaker Automobile plant in Detroit demanding weekly paychecks and an eight-hour day. Several days later, the company agreed to allow workers to draw a pay advance between checks, but denied them the eight-hour day. This was the automotive industry's first strike.

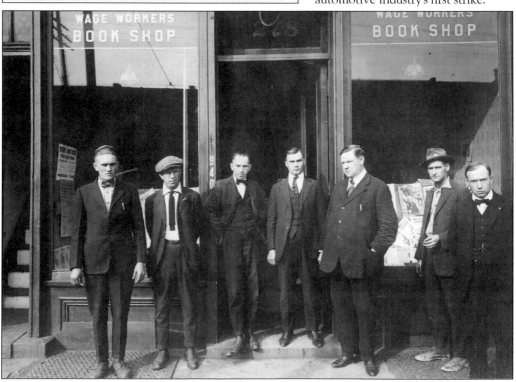

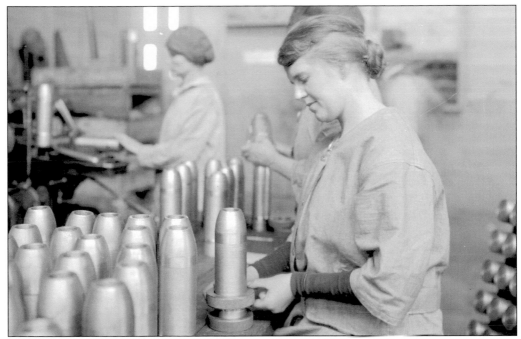

**WOMEN WORKERS MAKING MUNITIONS AT THE MAXWELL MOTORS FACTORY IN DETROIT DURING WORLD WAR I, 1917.** America's entry into World War I meant opportunity for many women workers. When men left their jobs in Detroit's factories and joined the armed forces, large numbers of women were hired to perform jobs previously considered suitable only for men. Most lost these jobs when the men returned from the war.

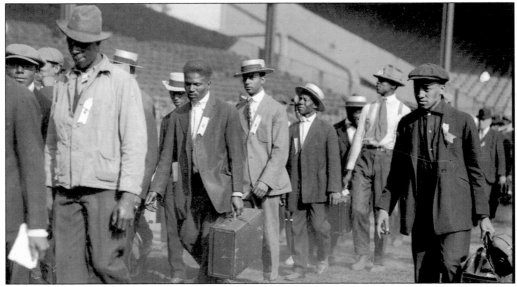

**AFRICAN-AMERICAN MEN LEAVING DETROIT FOR CAMP CUSTER IN BATTLE CREEK, MICHIGAN, C. 1917.** The World War I era also offered some opportunity for African Americans in Detroit. While some joined the armed forces, others found jobs in the city. Detroit's African-American population grew from about 5,000 to over 40,000 during the war years. By 1930 Detroit's black population numbered over 125,000.

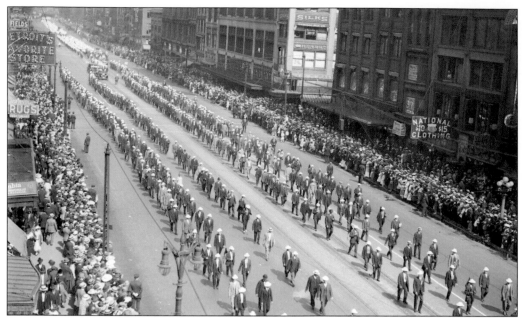

**DETROIT LABOR DAY PARADE, C. 1915**. Although still considered an open shop town, a place where unions held little power over employers, the labor movement still held its parade on Labor Day. In general, during this era until the onset of the Great Depression in October 1929, work was plentiful and wages were good.

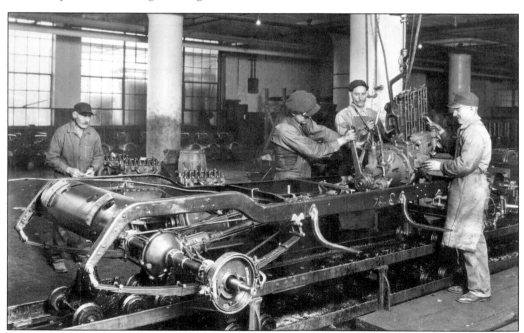

**GENERAL MOTORS ASSEMBLY PLANT IN DETROIT, 1922**. At the time of the Depression, almost one in every six jobs in the United States was dependent upon the fortunes of the automobile industry. Within a few months after the stock market crash, over 250,000 autoworkers lost their jobs. Until World War II pulled America out of the Depression, automotive jobs were scarce, and once obtained, prone to frequent layoffs.

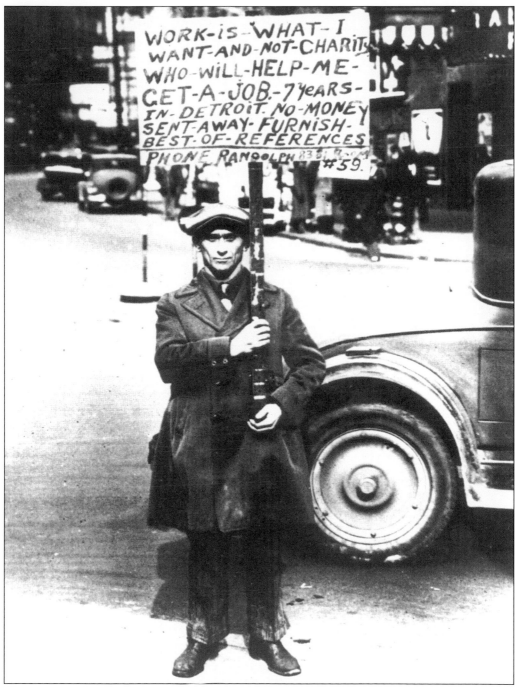

**UNEMPLOYED MAN IN DETROIT DURING THE GREAT DEPRESSION, C. 1930.** In October of 1929 the stock market suffered a severe crash, plunging the United States and the world into a decade-long depression. At its nadir, about 25 percent of the American workforce was unemployed. As usual, the working class was the first affected, but unlike previous recessions and panics, many middle-class and upper-class people also lost their jobs.

## OUR DUG-OUT CIVILIZATION

These unemployed workers have constructed these dug-outs along the railroad tracks in a Detroit city dump. By the use of discarded dump-truck bodies, these workers have provided their "winter homes". A lard can for a stove, rags and newspapers for a bed, make up the furnishings. Such a dug-out as seen in View No. 2 will furnish shelter for four men.

The Law of Supply and Demand, the bulwark of orthodox economy seems to have crumbled. With 41,000 homes vacant in Detroit, we find thousands of people living in hovels, shacks, and dug-outs because unemployed can't pay rent. On October 17, 1932 the Detroit Police Department reports finding in one precinct 1,500 homeless workers sleeping in parks, alleys, and other out-of-door places. Evidently the orthodox economist did not anticipate that the towering wall of private profit, avarice, and greed would make the equilibrium of supply and demand impossible.

View No. 4. A Coupon-clipper's home in contrast with that of a Worker.

"EVERYTHING GOES TO HIM WHO WANTS NOTHING".

---

WALTER AND VICTOR REUTHER'S OBSERVATIONS OF THE DEPRESSION IN DETROIT, 1932. Future leaders of the United Automobile Workers union Walter and Victor Reuther wrote these words about the Depression in Detroit. The two photographs on page 43 were taken by the Reuther brothers and accompanied the written passage on this page.

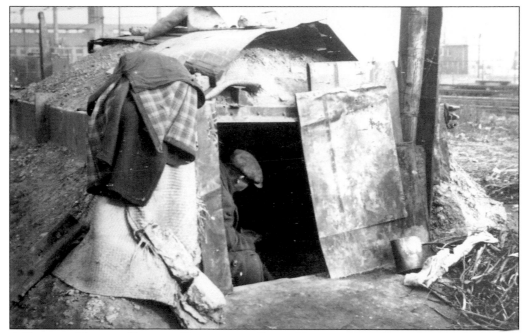

**A Dugout Home in Detroit During the Great Depression, 1932.** Like many American cities Detroit had its "Hoovervilles." These were makeshift cities constructed from discarded materials and named after President Herbert Hoover, who was president of the United States when the Depression began. Unemployed men and women and often whole families lived in these squalid and unhealthy surroundings.

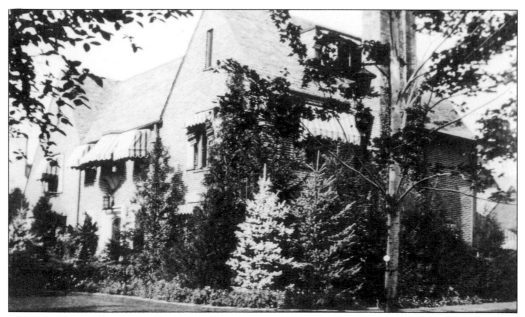

**Middle-Class Home in Detroit During the Great Depression, 1932.** The Reuther brothers took this picture of a middle-class home on a quiet street in Detroit to juxtapose it against their pictures of dugout homes. Such scenes left a lasting impression upon the Reuther brothers and many other Americans.

# SOCIAL SUICIDE

These views depict a few of the children who live in the back alleys of our civilization. Their jovial smiles at being photographed reflects their innocence of what lies ahead in their struggle for existence.

"They do not easily rise whose abilities are repressed
by poverty at home." -- Juvenal.

Under the irresistable grind of poverty, those smiling faces will, like plastic clay, be distorted into masks of human want and destitution. In the wealthiest country in the world, the "land of freedom and equal opportunity", at the height of our myth-prosperity, thousands of children were habitually hungry and habitually in rags. With the complete loss of their meagre income through unemployment, these families who were living on the margin of subsistence, have been forced over the abyss of human existence.

We are committing social suicide by tolerating a system that is starving millions of children. Teachers in the Detroit Public School System testify that many of their pupils can not attend school because of lack of food and clothing, while others who manage to drag themselves to school collapse in the classroom due to malnutrition. The insanity of this tragic situation is that while millions starve, our Government through its Farm Board advocates the burning of wheat; while millions freeze in their rags, this same Farm Board tells the cotton farmer to plough under every third row of cotton. Under the profit system where coordination of consumption and production are impossible, mass production means mass starvation.

WALTER AND VICTOR REUTHER'S OBSERVATIONS OF THE DEPRESSION IN DETROIT, 1932. Future leaders of the United Automobile Workers union Walter and Victor Reuther wrote these words about the Depression in Detroit. The two photographs on page 45 were taken by the Reuther brothers and accompanied the written passage on this page.

**AFRICAN-AMERICAN CHILDREN IN A POOR NEIGHBORHOOD IN DETROIT DURING THE GREAT DEPRESSION, 1932.** Children of the unemployed were especially affected during the Depression. During this era, for the first time, the federal government initiated programs to provide relief to urban America. Before then, all welfare programs were local.

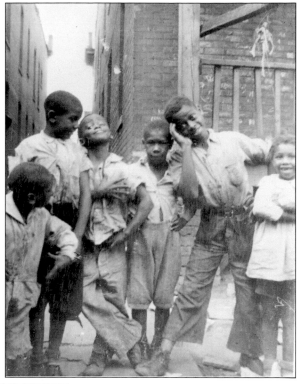

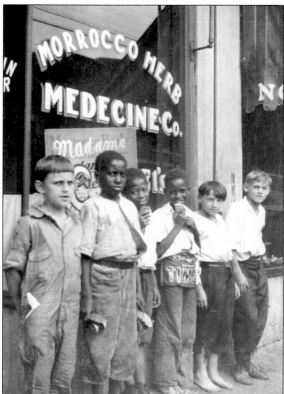

**CHILDREN IN A POOR NEIGHBORHOOD IN DETROIT DURING THE GREAT DEPRESSION, 1932.** The Reuther brothers were very concerned over the plight of children during the Depression. At the time, they were members of the Socialist Party and advocated massive intervention by the federal government to clothe and feed children during the Depression

45

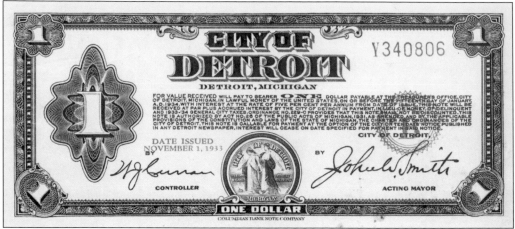

**SCRIP ISSUED BY THE CITY OF DETROIT IN 1933.** With its financial well-being dependent upon the success of the automobile industry, the City of Detroit almost went bankrupt during the Depression's worst moments. In 1932 and 1933, about 50 percent of its workforce was unemployed. When there was not enough money to pay city workers, Detroit issued scrip or a paper "IOU" to be used in place of U.S. currency.

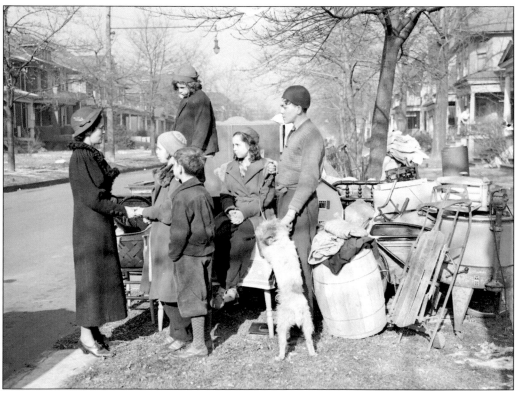

**FAMILY AFTER EVICTION FROM THEIR DETROIT HOME, 1937.** Although the worst years of the Depression were over by 1935, many Detroit families still did not have steady income. After several years of improvement, the American economy suffered a setback in 1937, the year this family was evicted from their home.

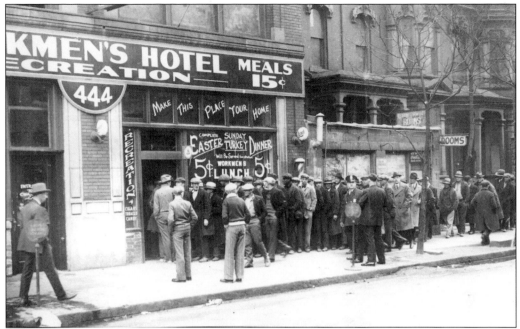

WORKMEN'S HOTEL ON HOWARD STREET IN DETROIT, C. 1930. Soon after the Depression threw millions out of work, soup kitchens or centers such as the Workmen's Hotel in Detroit provided unemployed with free or cheap meals and shelter. This establishment was owned and operated by a socialist political organization until 1932.

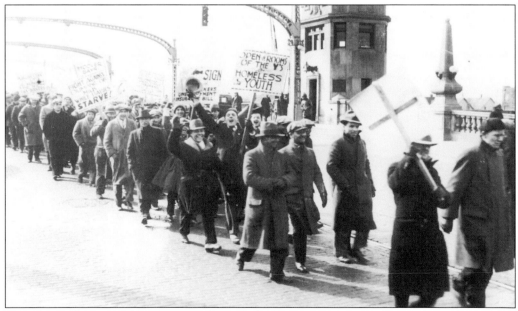

THE FORD HUNGER MARCH, 1932. During the Depression, many rallies and protest marches were held in Detroit. The most famous was the Ford Hunger March. On March 7, 1932, 3,000 to 5,000 demonstrators marched from the west side of Detroit to the gates of Ford's River Rouge plant. Once at the gates of the Rouge, members of Ford's notorious Service Department confronted them, led by ex-prizefighter Harry Bennett.

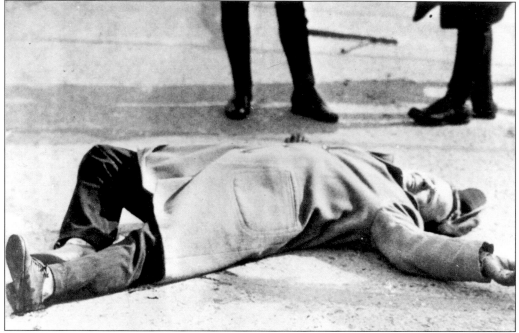

MAN INJURED DURING THE FORD HUNGER MARCH, 1932. At the gates of the River Rouge plant, words were exchanged between marchers and Ford Service Departments employees. Each claimed the other group began the ensuing violence. After a brick was thrown toward Harry Bennett, Ford's Service Department Employees began firing tear gas and machine guns at the marchers. Five demonstrators died of their wounds and dozens were injured.

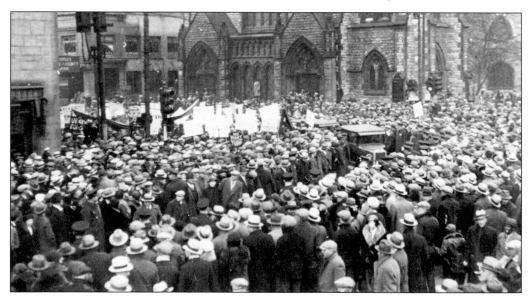

FUNERAL PROCESSION FOR THE HUNGER MARCHERS KILLED OUTSIDE THE ROUGE PLANT, 1932. Thousands of people lined the sides of Woodward Avenue to watch the funeral procession for the fallen Ford Hunger Marchers. Many of the signs carried by those in the procession urge onlookers to join the Auto Workers Union, a forerunner of today's United Automobile Workers union (UAW).

**PRESIDENT FRANKLIN ROOSEVELT AND DETROIT MAYOR FRANK MURPHY, 1932.** When Franklin Roosevelt became president in 1933, he declared that Americans would get a New Deal. He immediately launched into a series of governmental programs designed to create jobs and relieve poverty and hunger. Both he and Detroit Mayor Frank Murphy were sympathetic to the goals of the growing labor movement. In 1937–38, Murphy was governor of Michigan.

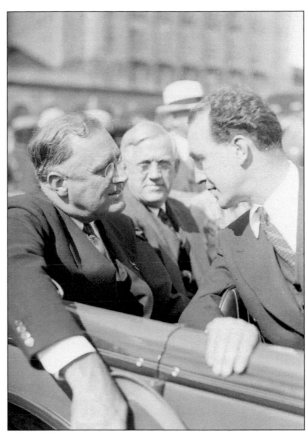

**WORKERS INVOLVED IN A WORKS PROGRESS ADMINISTRATION PROGRAM IN DETROIT, C. 1935.** President Franklin Roosevelt's administration initiated a number of federal programs designed to create work and relieve poverty. One such endeavor was the Works Progress Administration that provided money to employ workers to construct public buildings and roads, and provide jobs in other fields. These programs were also open to African Americans.

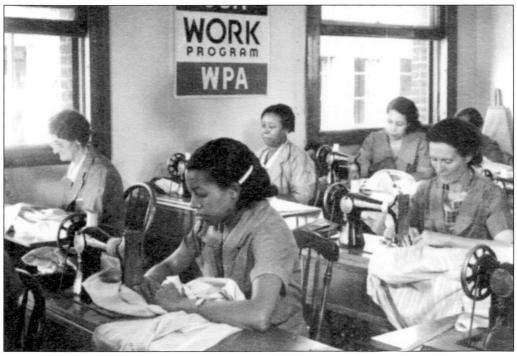

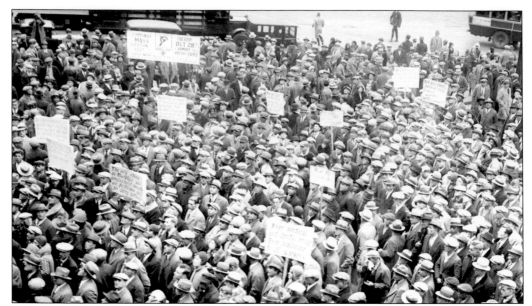

MASS RALLY OF UNEMPLOYED WORKERS IN DOWNTOWN DETROIT SPONSORED BY THE COMMUNIST PARTY, 1930. During the Depression, unemployed workers often participated in rallies and demonstrations. Like other Americans, aside from jobs they sought answers to the question "how did this happen?" and solutions to the Depression so another one would never occur. Political organizations such as the Communist and Socialist Parties attracted many of these people.

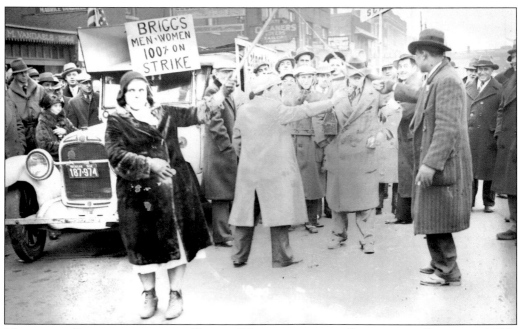

MARCHING STRIKERS FROM THE BRIGGS MANUFACTURING COMPANY IN DETROIT, 1933. The fledgling Auto Workers Union (AWU) staged a strike after a spontaneous walkout of 6,000 Briggs employees over wage cuts. Within hours, over 15,000 autoworkers were on strike, but it was unsuccessful. There were too many unemployed workers willing to take the jobs of striking workers. Aligned with the Communist Party, the AWU soon disappeared.

# *Three*

# DETROIT'S YEAR IN LABOR

# 1937

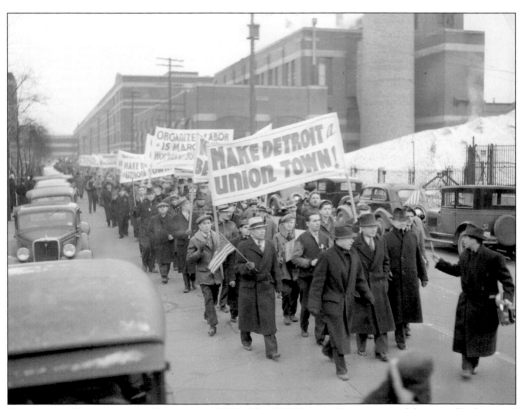

**MARCHING STRIKERS IN DETROIT, 1937.** The UAW members pictured here walked out of the General Motors Clark Street Cadillac Plant in January 1937. This picture shows them marching in support of the Flint Sit-Down which lasted from December 1936 to February 1937. In 1937, Detroit did indeed become a union town.

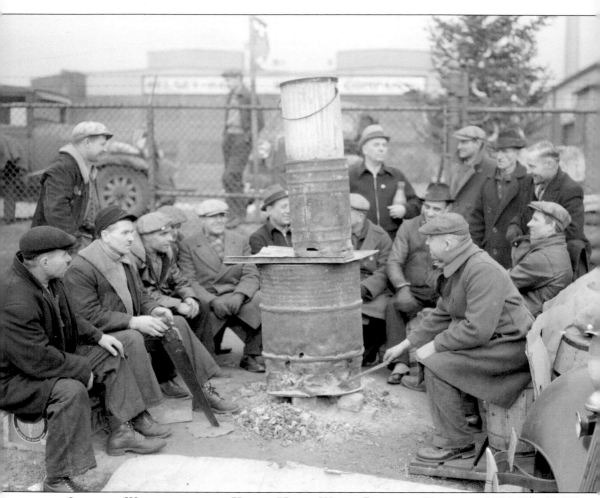

**STRIKING WORKERS AT THE KELSEY HAYES WHEEL PLANT IN DETROIT, 1936.** The UAW was established as an AFL affiliated union in 1935. A year later, it became an independent union and affiliated with the Congress of Industrial Organizations (CIO). The union's first important success was a strike in 1936 at the Kelsey Hayes Plant in Detroit. The fledgling labor leaders Walter and Victor Reuther led this strike.

**UAW Sit-Downers in Flint, Michigan, January 1937.** Pictured here are sit-downers inside a General Motors factory. On December 30, 1936, UAW members sat down at their jobs in Fisher Body plants #1 and #2 and refused to work or leave the factory. The Great Flint Sit-down had begun. Although this sit-down strike occurred in Flint, it was a momentous event that changed the course of labor history in Detroit.

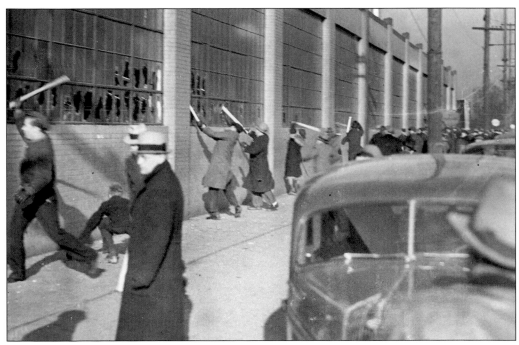

**UAW Picketers Busting Windows at Chevrolet Plant #9, February 1937.** Police attacked the workers inside Chevrolet Plant #9, firing tear gas into the factory. This picture shows UAW members breaking windows to let fresh air into the plant. During the battles at Plant #9, UAW members quietly occupied Chevrolet Plant #4. This factory supplied engines to almost all Chevrolet Assembly Plants in the United States.

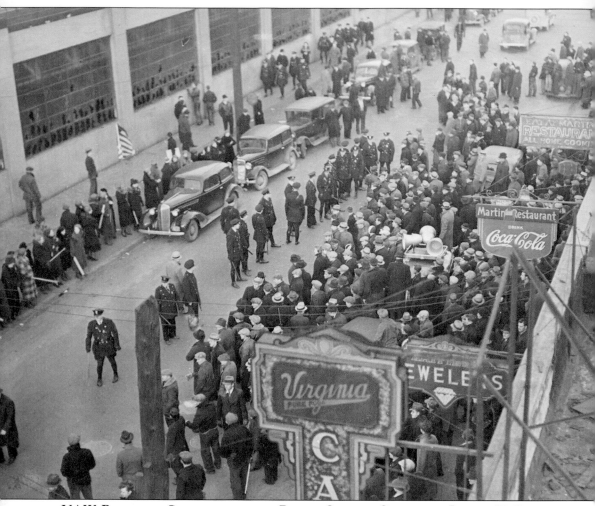

**UAW Picketers Confronting the Police Outside Chevrolet Plant #9, February 1937.** On February 1, 1937, UAW leaders circulated a rumor that sit-downers were planning on taking over Chevrolet Plant #9. Informers told company officials about the plan. This picture shows police and company security men surrounding the plant, confronting UAW picketers. Journalists also heard the rumor and captured the moment on film.

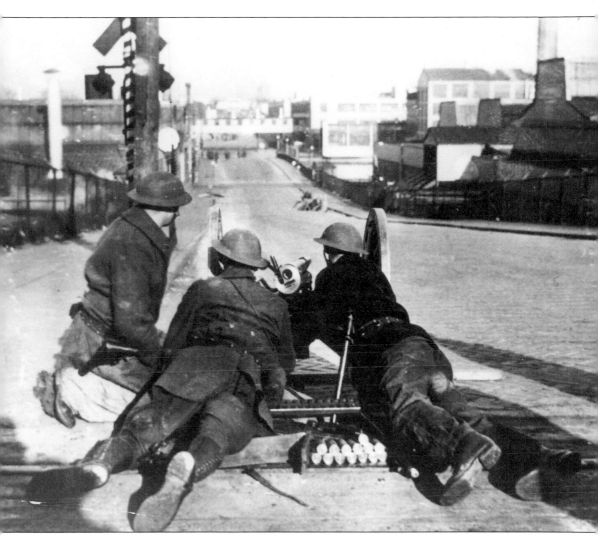

**THE MICHIGAN NATIONAL GUARD AT THEIR POST IN FLINT, FEBRUARY 1937.** After the confrontation between police and UAW sit-downers at Chevrolet Plant #9, the Michigan National Guard closed off the area surrounding the factories occupied by the sit-downers. Instead of removing the strikers from the plants, Michigan Governor Frank Murphy ordered the Guard to maintain the peace and not allow violent actions from either side of the conflict.

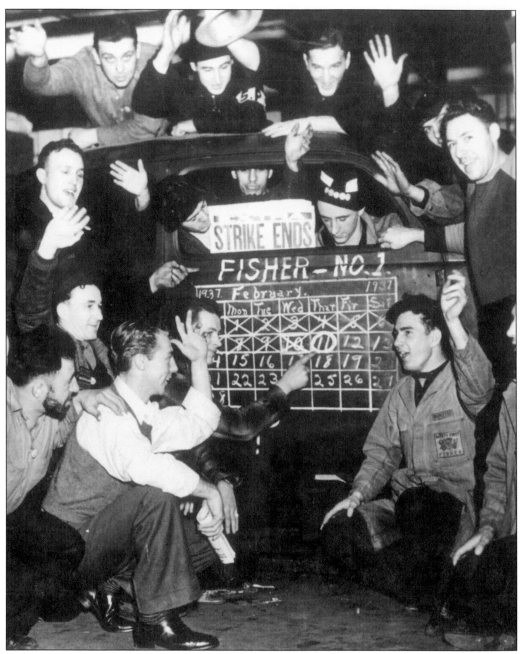

SIT-DOWNERS AND THEIR STRIKE CALENDAR ON THE LAST DAY OF THE SIT-DOWN, FEBRUARY 11, 1937. The UAW's strategy worked. The plants occupied by the sit-downers provided crucial parts for GM factories around the United States. As the sit-down dragged on, parts became scarce and other GM factories began to halt production. Within a few weeks, over 90 percent of the company's factories lay idle. GM had turned off the heat and water in the plants, its security forces and Flint Police had fought pitched battles with the strikers, and it had tried to use the courts to end the strike. The sit-downers, however, were steadfast and refused to give up. Finally, after 44 days, GM capitulated and signed a one-page contract that recognized the UAW as the sole bargaining agent for its members. The Great Flint Sit-down was over.

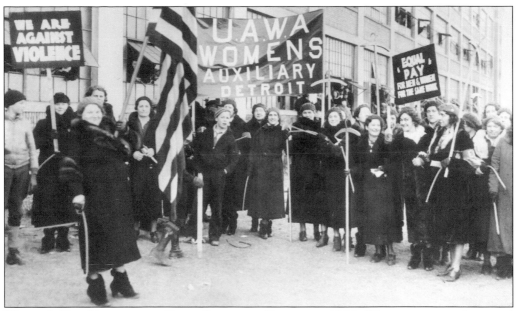

**WOMEN'S DAY DURING THE FLINT SIT-DOWN, FEBRUARY 1937.** Wives, sisters, mothers, and girlfriends of sit-downers supplied crucial support to the cause. They spirited food, clothing, blankets, and other necessities into the occupied plants. The Women's Emergency Brigade, formed by Genora Johnson, not only provided support for the strikers but, on several occasions, risked bodily harm when they placed themselves between police and the sit-downers.

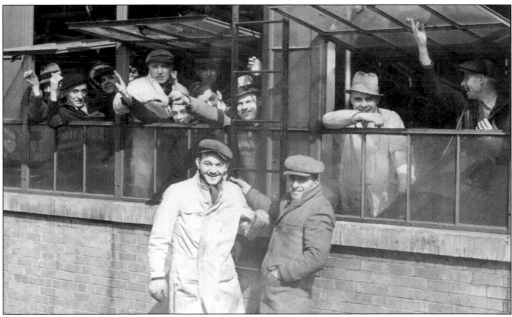

**SIT-DOWNERS AT THE PLYMOUTH PLANT IN DETROIT, MARCH 1937.** The success of the UAW Flint was the catalyst for a wave of sit-downs by Detroit workers in industries ranging from hotels and bakeries to cigar factories and automobile assembly plants. After General Motors, the UAW hoped to organize Chrysler Corporation and the Ford Motor Company. On March 8, 1937, UAW members sat-down in Chrysler's Detroit factories.

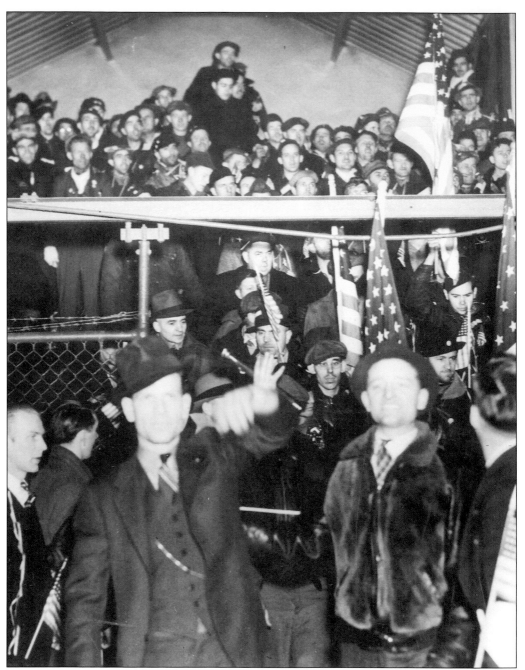

**Sit-Downers Leaving Chevrolet Plant #4, February 11, 1937.** The Flint Sit-Down was a great victory for the labor movement in America, and a defining moment for the UAW. Confronting General Motors was a great risk for the UAW—the union had yet to reach the second anniversary of its founding and in 1936 only had a few thousand members—but in the end, it forced the world's largest corporation to recognize the union as a legitimate organization. From this point in time until today, the UAW has been a force to be reckoned with in the automobile industry. Headquartered in Detroit, the UAW grew into one of the largest, most powerful unions in the world.

58

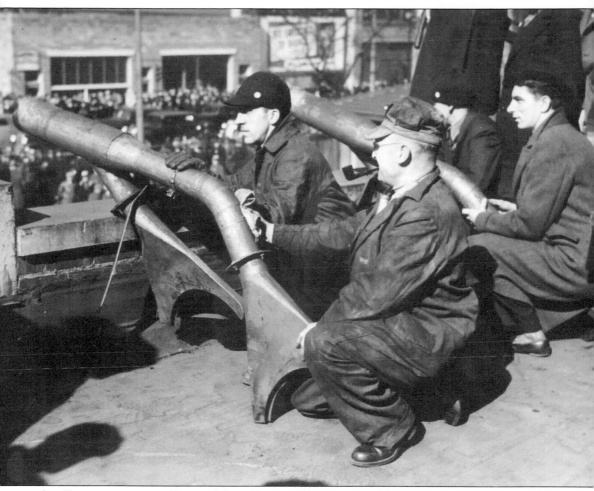

**SIT-DOWNERS AT THE DODGE MAIN PLANT, HAMTRAMCK, MICHIGAN, MARCH 1937.** The sit-downers pictured here have assembled mock or fake machine guns on the roof the Dodge Main plant. Learning from GM's actions in the Flint Sit-Down, Chrysler Corporation's leaders never called in the police, and unlike GM in Flint, maintained heat and water in its factories. A few days after the sit-down began, over 68,000 Chrysler workers were idled.

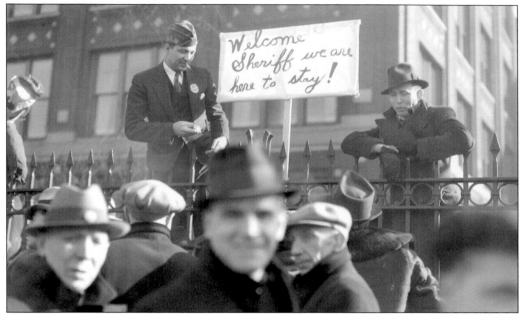

**UAW PICKETERS OUTSIDE A CHRYSLER PLANT, MARCH 1937.** The UAW also learned from the Flint Sit-Down. The union did its best to maintain peaceful protests, and it provided strikers with food and plenty of manpower for picket lines. The sign shown in this picture speaks to their resolve. Detroit's Chief of Police estimated that it would take 30,000 officers to remove sit-downers from Chrysler plants in the city.

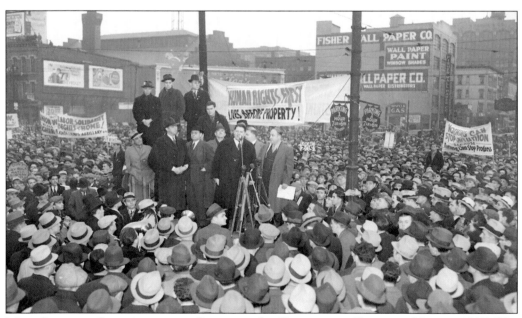

**MASS RALLY IN SUPPORT OF THE CHRYSLER SIT-DOWNERS IN DETROIT, MARCH 1937.** The Chrysler sit-downers also had support from many Detroiters at large. On March 23, 1937, a rally was held in Cadillac Square in downtown Detroit, near the old city hall. Over 100,000 demonstrators rallied in support of the strikers. Speaking at the microphone is UAW Vice President Richard Frankensteen.

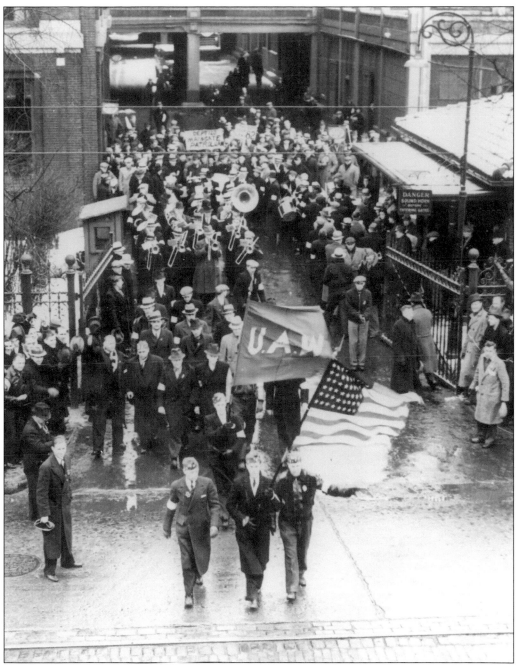

**SIT-DOWNERS LEAVING THE DODGE MAIN PLANT ON MARCH 25, 1937.** Although the strike was not settled until April 6, Chrysler agreed to cease all production until a contract was negotiated with the UAW. Jubilant workers left Dodge Main and other Chrysler plants on March 25, 1937. Now, two of the big three automakers—GM and Chrysler—recognized the union as the sole bargaining agent for its members. The success of the UAW as it led the largest sit-downs in American history resulted in thousands of new members for the union. The UAW then turned its attention to organizing Ford Motor Company. Henry Ford, however, hated unions and would not recognize the UAW until 1941.

**SIT-DOWNERS AT WOOLWORTH'S IN DETROIT, FEBRUARY 1937.** Following the UAW's success in Flint, many workers in Detroit decided to stage sit-downs. Estelle Gronie Cassily, who worked in a Detroit cigar factory, summarized the moment: "And we figured if they can do it, we can also do it." On February 28, workers at Woolworth's dime store in downtown Detroit began an eight-day sit-down strike.

**SIT-DOWNERS AT WOOLWORTH'S IN DETROIT, FEBRUARY 1937.** The sit-down at Woolworth's began on February 28 when an organizer from the AFL's Waiters and Waitresses Union entered Woolworth's downtown store and gave the prearranged signal. He blew a whistle and shouted: "Strike, girls, strike!" More than 250 women, from clerks to lunch-counter waitresses, sent customers and management home and barricaded themselves inside the store.

**WOOLWORTH'S SIT-DOWNERS PLAYING CARDS, FEBRUARY 1937.** The sit-down at Woolworth's caught the attention of the national media. Reporters and photographers from *Life* magazine and *Pathe* newsreels came to Detroit and soon the Woolworth strikers were front-page news around the nation. Although this was a highly publicized sit-down, it was only one out of over 100 staged in Detroit between February and June 1937.

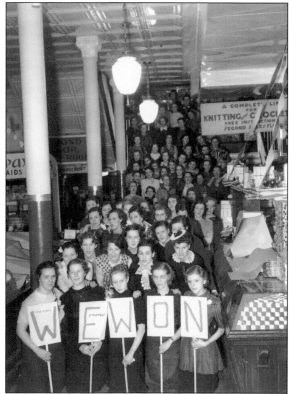

**END OF THE WOOLWORTH'S SIT-DOWN IN DETROIT, MARCH 6, 1937.** After Woolworth workers seized another store on March 6, the peaceful sit-down ended with a 5¢-an-hour wage increase, recognition of the Waiters and Waitresses Union, a paid annual vacation, and other improved benefits. The Woolworth's sit-down also inspired other retail and restaurant workers Detroit, many of who soon staged their own sit-downs.

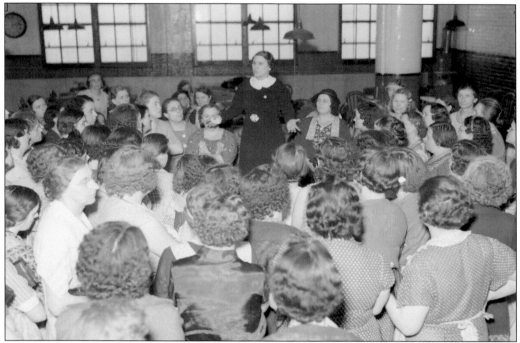

**MARY ZUK ADDRESSING STRIKING CIGAR MAKERS IN DETROIT, 1937.** Cigar makers, largely females who were Polish immigrants or first-born Polish Americans, were among the first workers in Detroit to join the wave of sit-downs. One of them was Mary Zuk, who was also president of the "Polish Workers Local 187," an early UAW local.

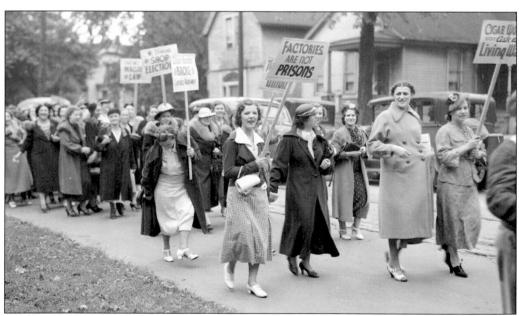

**STRIKING CIGAR MAKERS MARCHING IN DETROIT, 1937.** By February 20, 1937, over 2,000 women occupied five cigar factories in the city. They had a list of grievances regarding wages, benefits, and work conditions. By early March, two cigar companies had settled with workers and recognized the Cigar Makers International Union as the official bargaining agent for its members.

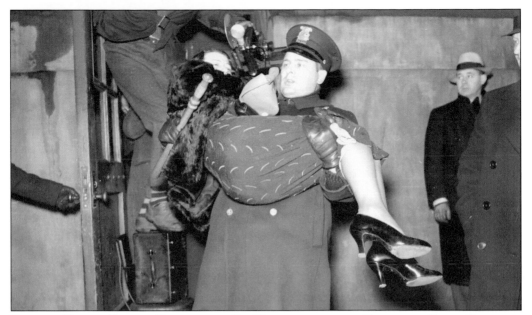

**DETROIT POLICE OFFICER REMOVING A SIT-DOWNER FROM THE SCHWARTZ CIGAR FACTORY, 1937.** Not all sit-down strikes were successful. On March 20, 1937, over 300 Detroit Police officers removed 200 strikers from the Bernard Schwartz Cigar Factory. Outside the factory, 40 mounted policemen fought with a large crowd of sympathizers. Six men and one woman were sent to the Detroit Receiving Hospital for medical aid.

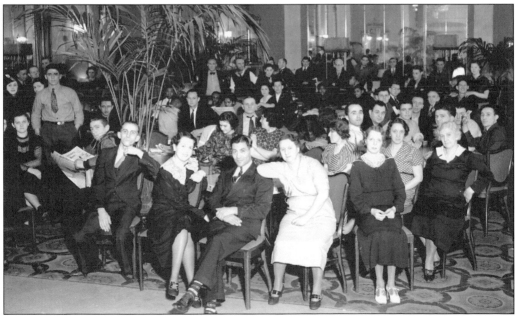

**SIT-DOWNERS AT THE STATLER HOTEL IN DETROIT, 1937.** The Depression hurt Detroit's hotels. Many of them paid their workers $1 per day or less. On March 15, 1937, organizers from five AFL unions called a strike and 400 employees sat-down in the Statler. Detroit's Hotel Association decided to call a "lock-out." This meant that they attempted to clear all workers out of their hotels before sit-downs could be staged.

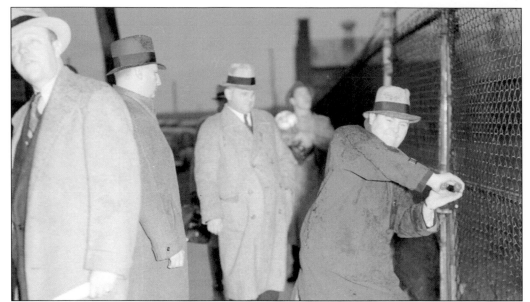

**POLICE CUTTING THE LOCKS ON THE YALE & TOWNE MANUFACTURING COMPANY GATES, APRIL 1937.** On April 14, 1937, police broke through the gates of the Yale & Towne Manufacturing Co. and began removing striking sit-downers. As in many of the sit-downs in Detroit, most of the strikers were women.

**SIT-DOWNERS AT YALE & TOWNE MANUFACTURING COMPANY, APRIL 1937.** The strikers pictured here have barricaded themselves inside the Yale & Towne factory. They are watching the police cut the locks on the factory's gates. Ironically, the Yale & Town Manufacturing Company made padlocks.

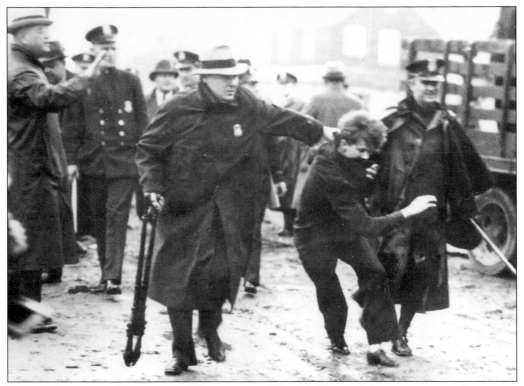

**POLICE EVICTING A STRUGGLING WORKER FROM YALE & TOWNE MANUFACTURING COMPANY, APRIL 1937.** The 135 sit-down strikers refused to obey a court's order demanding their evacuation. Over 400 police cleared the plant after a pitched battle with the strikers. Although many sit-downs in Detroit were successful, unions and their organizers also suffered a number of losses.

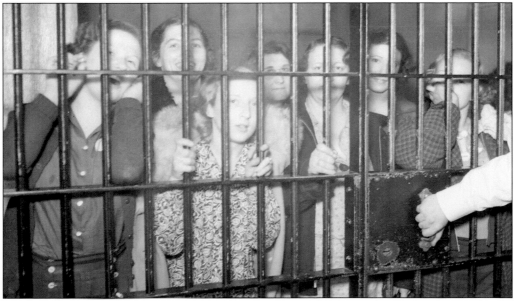

**STRIKERS FROM THE YALE & TOWNE MANUFACTURING COMPANY SIT-DOWN BEHIND BARS, APRIL 1937.** After the police raided the Yale & Towne factory, strikers spent a little time in jail.

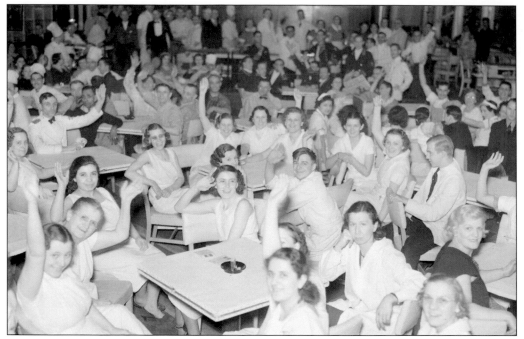

SIT-DOWNERS AT THE BOOK CADILLAC HOTEL IN DETROIT, MARCH 1937. Shortly after strikers occupied the Statler Hotel, the Detroit Hotel Association declared a "Lock-out." The Waiters and Waitresses Union however led a bold invasion of the Book Cadillac Hotel. Pushing past several policemen, 60 activists joined workers inside the hotel. Governor Frank Murphy arranged a truce between the Association and Book Cadillac strikers, which called for union recognition and wage increases.

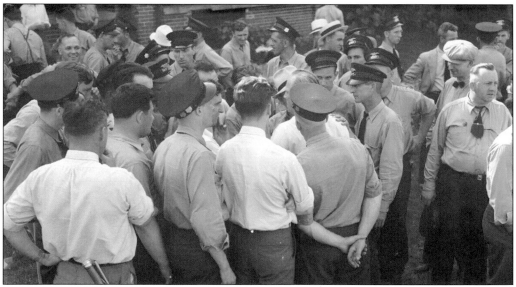

STRIKING BUS DRIVERS IN DETROIT, 1937. Not all strikes held in 1937 were sit-downs. Pictured here are bus drivers for the Detroit Street Railways, which was the city department responsible for public transportation. This strike was called by the Amalgamated Association of Street and Electric Railway Employees of America Union.

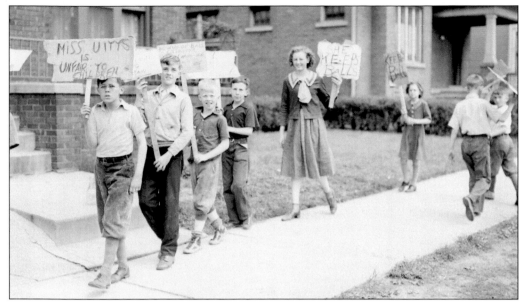

**CHILDREN STRIKERS IN DETROIT, 1937.** Even children in Detroit decided to join the labor movement's wave of strikes. This picture shows children picketing the home of a woman who took their baseball and would not give it back to them. By June, the wave of strikes was largely over, but not before Detroit gained its reputation as a union town. Indeed, 1937 was the year of Labor in Detroit.

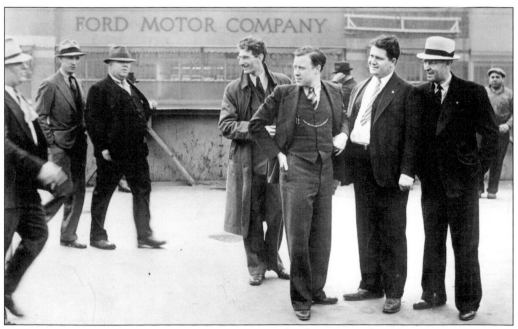

**THE BATTLE OF THE OVERPASS, MAY 26, 1937.** The famous Battle of the Overpass at Ford's River Rouge plant also put Detroit in the national spotlight in 1937. On May 26, UAW organizers, including (left to right) Robert Kantor, Walter Reuther, Richard Frankensteen, and J.J. Kennedy obtained permits to peacefully distribute leaflets to Ford workers on the Miller Road overpass. In this picture, they are looking at approaching Ford servicemen.

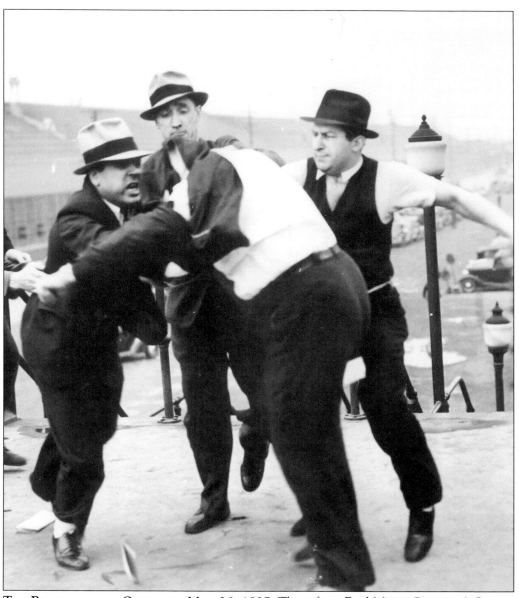

**The Battle of the Overpass, May 26, 1937.** Thugs from Ford Motor Company's Service Department pounced upon the UAW organizers, beating them and throwing Walter Reuther down the steps of the overpass. This picture shows servicemen beating Richard Frankensteen. A reporter from the *Detroit News* captured the event on film. As he ran to his car, Ford servicemen followed him. They told the reporter to give them his camera film or else. The reporter gave the thugs a blank roll of film instead, and within days, the photographs of the battle were published in newspapers around the world. This event gained tremendous sympathy for the UAW and the plight of its members at Ford Motor Company. This was also the first of Walter Reuther's many appearances in the media.

**THE BATTLE OF THE OVERPASS, MAY 26, 1937.** While Walter Reuther and other UAW organizers suffered a beating on the overpass, beneath it Ford servicemen fought a pitched battle for nearly 30 minutes with other UAW members. This picture shows Ford Servicemen removing a UAW organizer from the River Rouge plant area. After the battle was over, dozens of UAW members were treated for injuries.

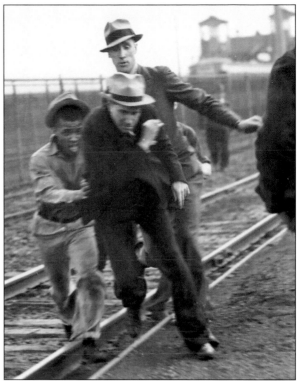

**AFTER THE BATTLE OF THE OVERPASS, MAY 26, 1937.** This picture shows (left to right) a bloody Walter Reuther and Richard Frankensteen after the Battle of the Overpass. Reuther recalled that: "The men picked me up about eight different times and threw me on my back on the concrete…kicking me in the face, head, and other parts of my body…finally, they threw me down the stairs…"

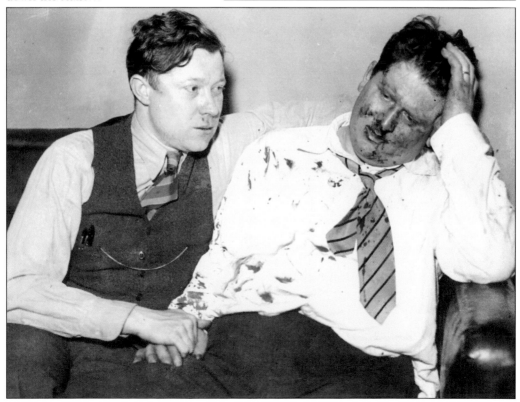

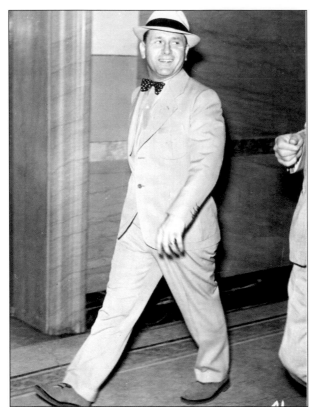

**HARRY BENNETT, 1937.** In the 1930s, Henry Ford placed Bennett in charge of industrial relations for Ford Motor Company. A former prizefighter and strikebreaker, Bennett built Ford's Service Department into one of the most brutal corporate security forces in history. Workers in Ford plants were watched by servicemen or their agents and suspected union sympathizers were harassed and fired, if not physically beaten.

**LABOR DAY PARADE ON WOODWARD AVENUE IN DETROIT, 1937.** The 1937 Labor Day Parade was a huge celebration with thousands of marchers. Union membership in the city had increased by tens of thousands during the year, and many new union locals were organized. The labor movement had much to celebrate in 1937.

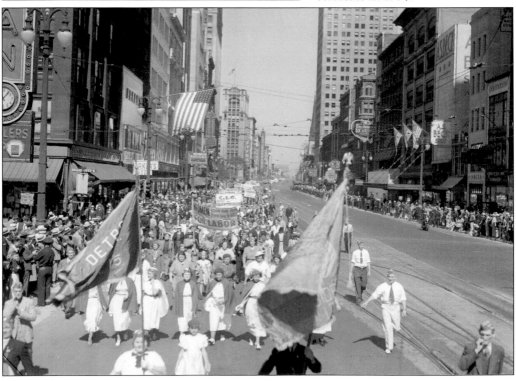

# Four

# LABOR AND THE
# ARSENAL OF DEMOCRACY

# 1937–1945

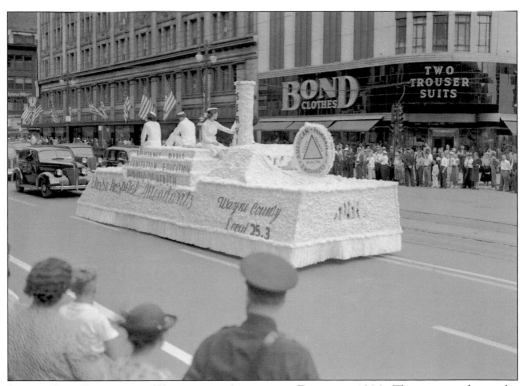

**LABOR DAY PARADE ON WOODWARD AVENUE IN DETROIT, 1939.** This picture shows the
American Federation of State, County, and Municipal Employees (AFSCME) float in the 1939
Labor Day Parade. At the same time, on September 1, 1939, World War II began in Europe.
America entered the war after Pearl Harbor was bombed on December 7, 1941. Soon, Detroit
would be known as the "Arsenal of Democracy."

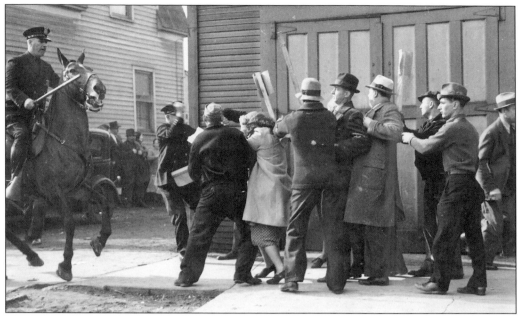

**MOUNTED POLICEMAN RIDING INTO A PICKET LINE AT FEDERAL SCREW COMPANY IN DETROIT, 1938.** The Federal Screw Company in Detroit laid off half of its workforce and cut the wages of remaining employees, prompting a strike in March 1938. Detroit Mayor Richard Reading, who won the election on an anti-labor ticket, ordered 400 policemen to escort strikebreakers into the plant. Despite the violence against it, the UAW survived at Federal Screw.

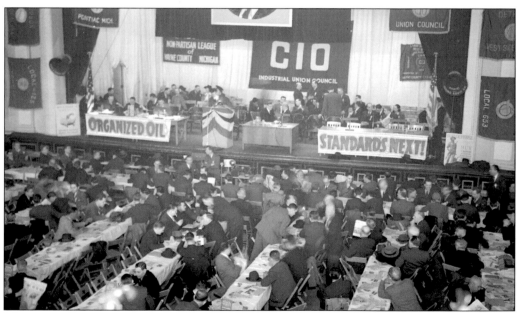

**MICHIGAN CONGRESS OF INDUSTRIAL ORGANIZATIONS CONVENTION (CIO), 1941.** The CIO was first formed in 1935 as the Committee of Industrial Organizing to promote industry-wide unions. The AFL, formed in 1886, organized craft unions based upon particular skills. Under this system, a factory might have several unions representing different trades. The CIO organized workers by industry, so that a single union represented a factory or an industry.

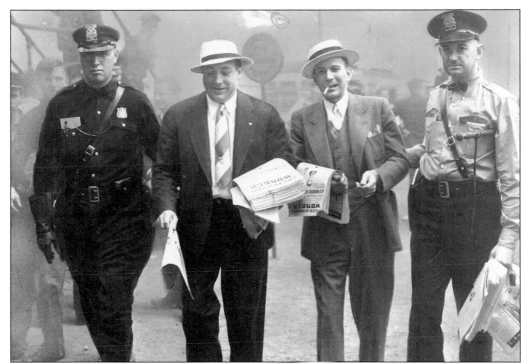

**UAW Officials Arrested at Ford's River Rouge Plant, June 1938.** The UAW had organized Chrysler and GM in 1937, but the biggest prize was Dearborn, Michigan, where Ford Motor Company bitterly resisted union efforts. This picture shows UAW Executive Board members R.J. Thomas and Fred Piper after they and 23 other organizers were arrested for distributing union literature at Ford's Rouge plant. Thomas was president of the UAW, 1939–1946.

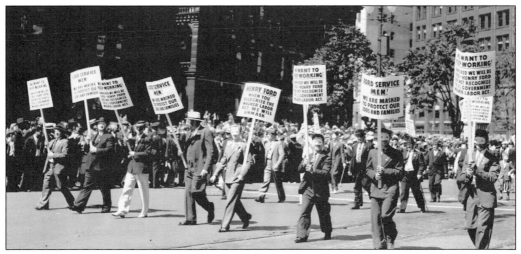

**Ford Workers Marching in the Detroit Labor Day Parade, 1939.** The UAW members pictured here are marching in the Labor Day Parade while wearing masks. Harry Bennett and his Servicemen ran Ford's production operations until 1945 and harassed and/or fired suspected UAW sympathizers. By 1939 Ford was the last of Detroit's major carmakers, including Hudson and Packard, to deny recognition to the UAW.

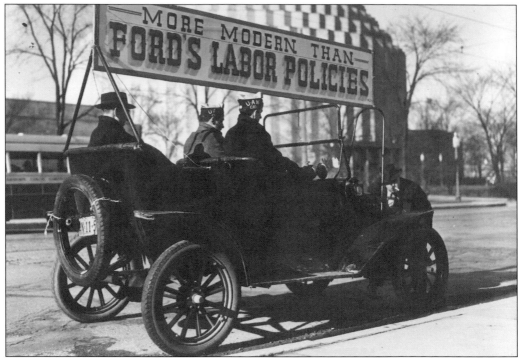

UAW ORGANIZERS DRIVING NEAR FORD MOTOR COMPANY HEADQUARTERS IN DEARBORN, MICHIGAN, 1941. The banner on this Model T summarizes the UAW perspective on the labor policies of Ford Motor Company. Ford produced the last Model T at the River Rouge plant in 1927. By this time, Ford's Service Department had grown to over 3,000 men.

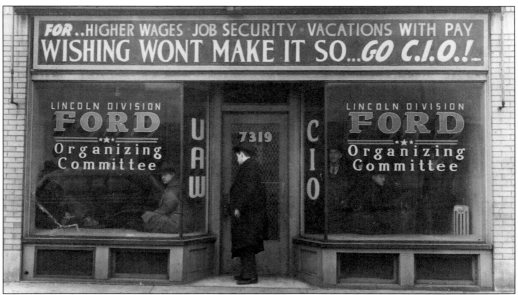

HEADQUARTERS FOR THE UAW'S ORGANIZING DRIVE AT FORD MOTOR COMPANY'S LINCOLN DIVISION, 1941. Lincoln Motors had been a division of Ford Motor Company since 1922. Its main factory was on Warren Avenue, near the western border of Detroit. Although the River Rouge plant was the UAW's primary focus, Lincoln also had to be organized.

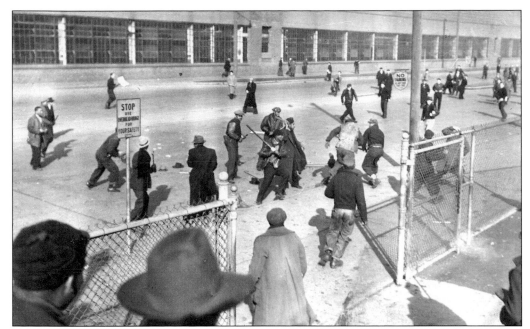

**AFRICAN-AMERICAN WORKERS BATTLE SERVICEMEN OUTSIDE FORD'S RIVER ROUGE PLANT, APRIL 1941.** When Harry Bennett fired eight men from the plant's rolling mill on April 1, 1941, a general work stoppage began. African-American workers at Ford were in a tough spot between the company and the UAW. Ford was one of the few companys that hired large numbers of black workers, but most of them supported the union.

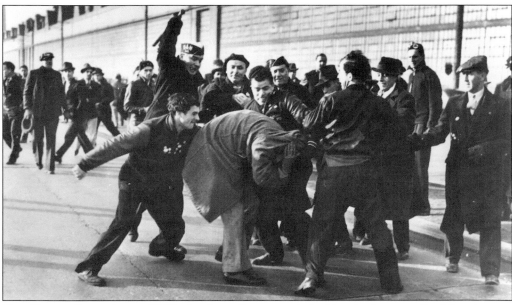

**THE PICKET LINE, APRIL 1941.** As the strike grew, pitched battles between Ford Servicemen and UAW members occurred near the Rouge plant. Harry Bennett attempted to characterize the strike as an action led by "Communist Terrorists," but by this time he had little credibility. This picture, "The Picket Line," by *Detroit News* photographer Milton Brooks, won the first Pulitzer Prize for photography in 1942.

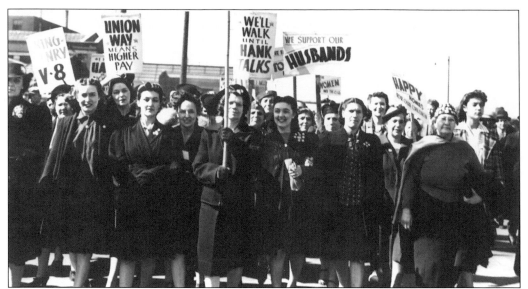

**WOMEN SUPPORTERS OF THE FORD STRIKERS, 1942.** Much like the Great Flint Sit-Down and many other strikes in Detroit, the wives, mothers, and girlfriends of striking Ford workers held parades, marched in picket lines, operated soup kitchens, and provided many other means of supporting the strikers. Their actions were crucial to the success of the labor movement.

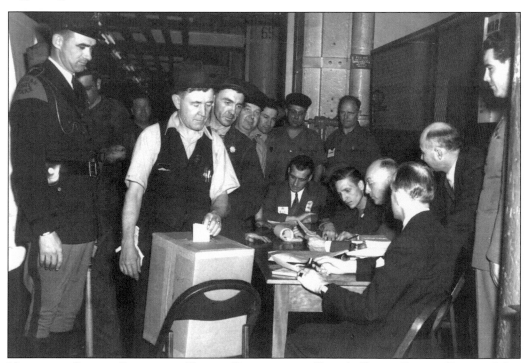

**NATIONAL LABOR RELATIONS BOARD ELECTION AT FORD'S RIVER ROUGE PLANT, MAY 1941.** A week after the strike began, Henry Ford agreed to hold a National Labor Relations Board election to determine if its employees really desired to have the UAW as their bargaining agent. The Wagner Act established the NLRB in 1935 to administer fair union elections for and arbitrate disputes regarding union recognition.

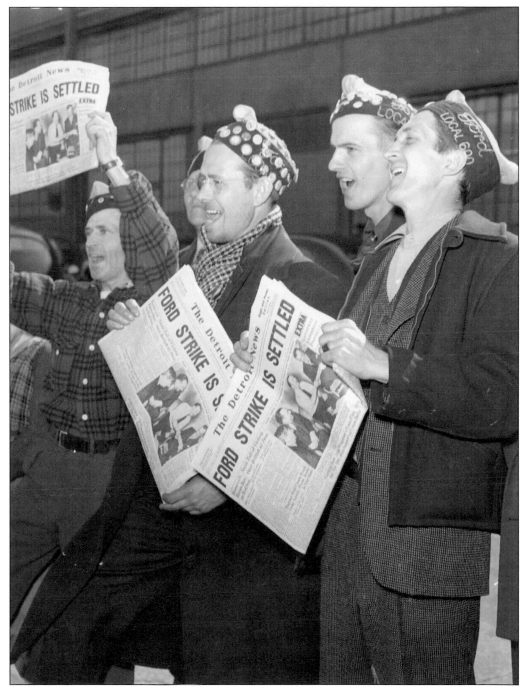

**THE END OF THE FORD MOTOR COMPANY STRIKE, APRIL 11, 1941.** The strike ended in April but in the NLRB election at Ford on May 21, 1941, 70 percent of the vote was in favor of the UAW. The strike was over and the UAW was now the official voice of the workers for the Big Three automakers: GM, Ford, and Chrysler.

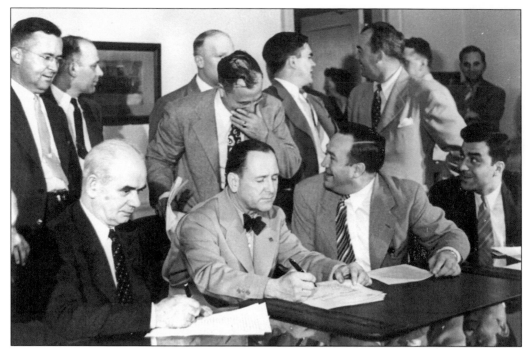

**SIGNING THE AGREEMENT BETWEEN FORD MOTOR COMPANY AND THE UAW, MAY 1941.** Pictured here is the signing ceremony that ended the 1941 Ford Strike. Seated from left to right are CIO President Philip Murray, Harry Bennett, UAW President R.J. Thomas, and UAW Secretary-Treasurer George Addes. When Henry Ford II took over the reins of the Ford Motor Company in 1945, one of his first actions was to fire Bennett.

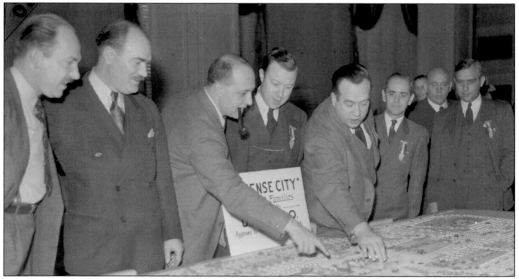

**PLANS FOR A "DEFENSE CITY" IN MICHIGAN, 1941.** America entered World War II after Pearl Harbor was bombed on December 7, 1941. Even before that famous day, however, labor and industry were planning for war. One primary issue for labor was housing required for a massive increase in industrial workers. Reviewing plans for a "Defense City" are Walter Reuther and R. J. Thomas (fourth and fifth from left).

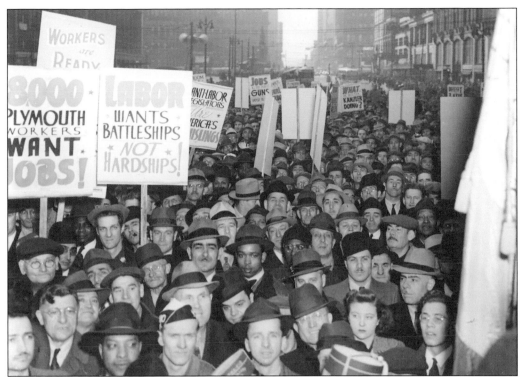

**LABOR RALLY IN CADILLAC SQUARE IN DETROIT, MARCH 1942.** This rally was staged on March 24, 1942, by workers protesting the slow pace of conversion to war work by the city's automobile companies. Having just lived through a decade-long Depression, workers were eager for jobs and eager to begin the process of winning the war. During the war, over 200,000 workers migrated to Detroit for jobs in the defense industry.

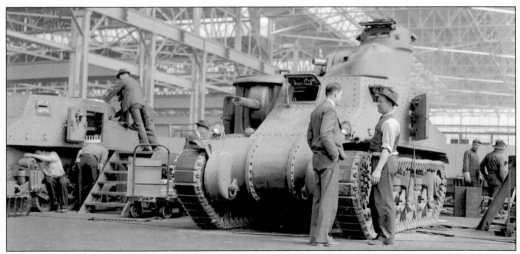

**INTERIOR OF CHRYSLER CORPORATION'S DETROIT TANK ARSENAL, WARREN, MICHIGAN, 1941.** Pictured here are workers and M-3 "General Lee" Tanks at Chrysler's Tank Arsenal. In August 1940, the U.S. Army agreed to build a tank plant and let Chrysler manage production. Steelworkers, ironworkers, and other tradesmen built the factory in six months. Chrysler autoworkers completed their first tank in April 1941.

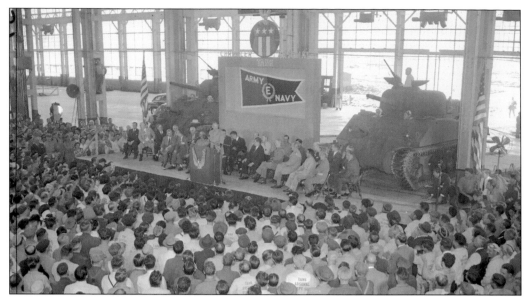

**INDUSTRIAL AWARDS CEREMONY AT THE DETROIT TANK ARSENAL, 1942.** Prior to the completion of the Detroit Tank Arsenal in 1941, Detroit autoworkers had no experience building tanks. By 1942, the men—and women—of the Arsenal had built 2,000 tanks. This picture shows Tank Arsenal workers receiving an armed forces "E" flag for excellence in production. The Arsenal was the first defense plant in America to win this award.

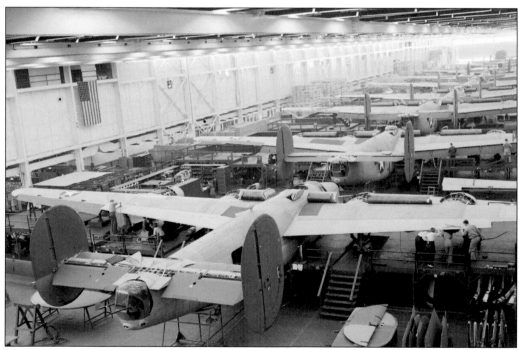

**B-24 LIBERATOR BOMBERS ON THE ASSEMBLY LINE AT FORD'S WILLOW RUN PLANT, C. 1943.** In 1940, Ford built a bomber assembly plant in Willow Run Township near Ypsilanti, Michigan. Its one-mile long assembly line was the longest in the world. After a slow start, this plant was producing a bomber an hour by the end of the war. Over 8,000 B-24s were built at Willow Run.

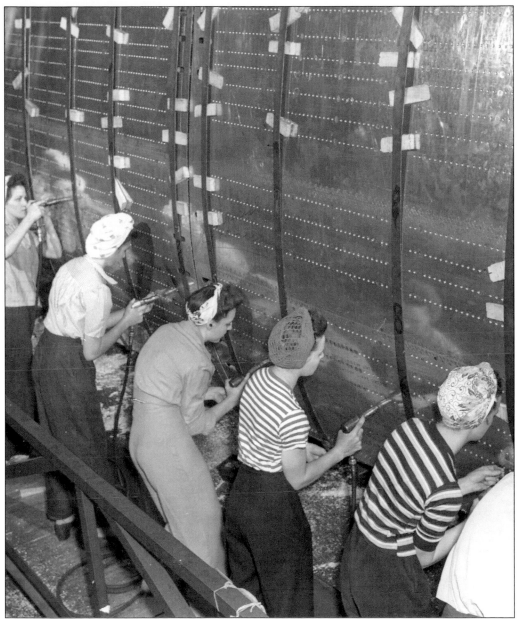

**WOMEN WORKING ON AN AIRCRAFT WING, C. 1944.** When over 200,000 men left Detroit's factories to serve in America's armed forces, an opportunity was created for women and African Americans. These groups were able to fill industrial jobs usually denied to them. When the Willow Run plant began operations, almost overnight over 40,000 workers were needed to build bombers. About 20,000 skilled workers came from Detroit each day along the Detroit Industrial Highway; another 20,000 settled in quickly built government housing near Ypsilanti, Michigan. Many women were hired at Willow Run. These were the famous "Rosie the Riveters." African Americans did not fare as well. Most of the workers who moved to Willow Run were white men from Appalachia and other parts of the South who brought their prejudices with them to Michigan. Because of their actions and threats, only a few African Americans gained employment at Willow Run.

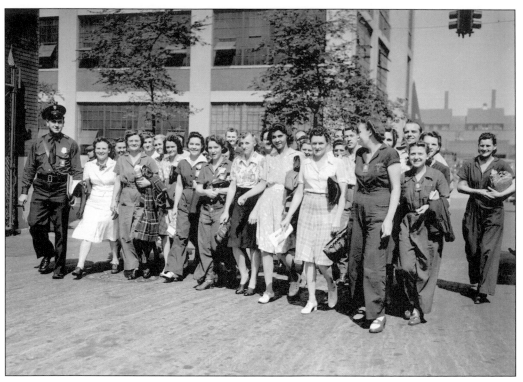

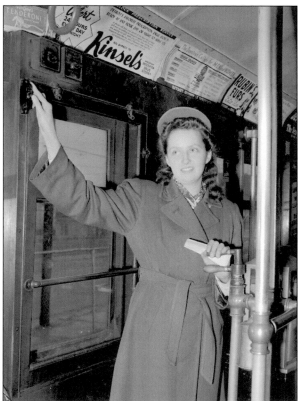

**WOMEN WAR WORKERS GOING TO WORK AT GENERAL MOTOR'S CLARK STREET CADILLAC PLANT IN DETROIT, 1942.** Women had first entered the industrial workforce in significant numbers during World War I. It was during World War II, however, that large numbers gained industrial jobs. When men returned from service in the war this time, however, women were reluctant to give up their jobs in Detroit's factories.

**FIRST WOMAN "CONDUCTORETTE" IN DETROIT, 1942.** Not all jobs in Detroit were in heavy industry, and women were needed to replace men who joined the armed forces from many different occupations. Pictured here is Detroit's first female street railway conductor. During the war, there were many "firsts" such as this for women in Detroit.

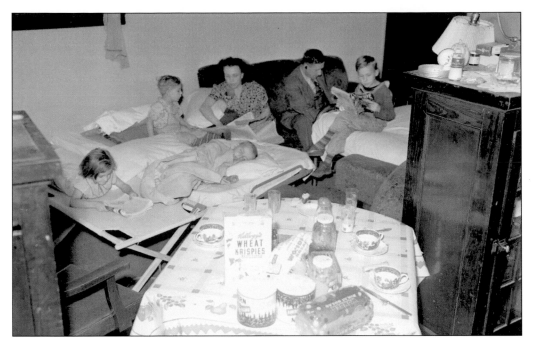

**FAMILY LIVING IN WAR HOUSING IN DETROIT, C. 1943.** During the war, hundreds of thousands of people moved to Detroit to find work in defense plants. Temporary war housing was constructed in many parts of the metropolitan area to provide shelter for these crucial war workers. Pictured here is part of an 11-member family living in a two-room apartment.

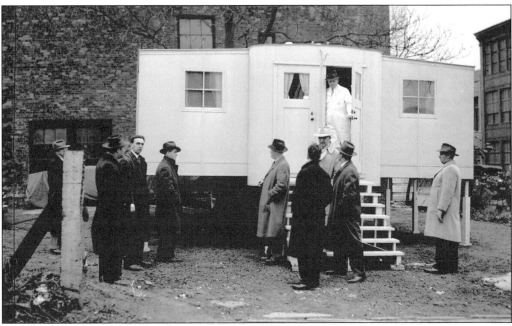

**NATIONAL DEFENSE HOUSING ON VIEW AT THIRD AND CONGRESS AVENUES IN DETROIT, 1942.** This picture shows a typical defense housing project in Detroit. Cheaply and quickly constructed and located near defense factories, such housing was home for thousands of workers during the war.

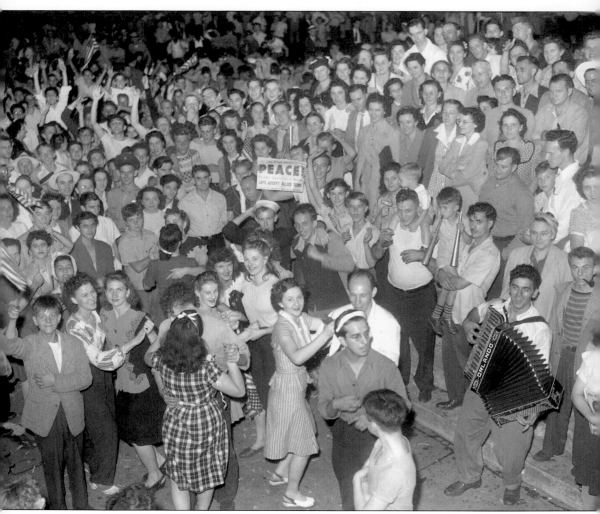

**V-J Day Celebration in Detroit, August 1945.** These Detroiters are celebrating the Allies' victory over Japan and the end of World War II. After the war, Detroit's automakers and other businesses reconverted their factories to resume civilian production. There was, however, some unrest among workers in the city and across America. Most had labored throughout the war with minimal or no increase in wages and in dangerous work conditions. Most unions had also given the U.S. government a no-strike pledge; that is, they agreed not to strike until the war was over. Near the end of the war, however, there were a number of "wildcat strikes," or spontaneous strikes that were not authorized by union leadership. As the war neared its end, unions turned their attention to building the labor movement, solidifying the gains they had made before and during the war, and dealing with such social issues as housing and jobs for returning veterans.

# Five

# LABOR GROWS UP

# 1945–1960

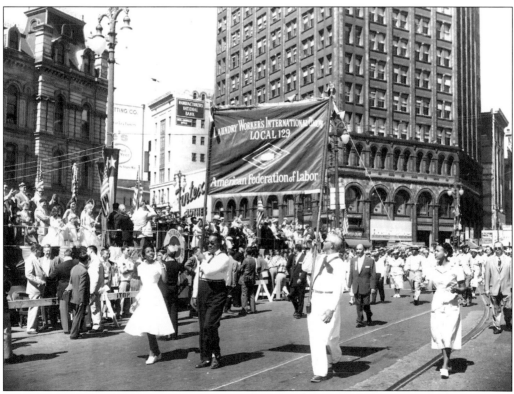

**LABOR DAY PARADE IN DETROIT, 1956.** By this time the Detroit Labor Day Parade was one of the largest Labor Day celebrations in America. There was much to celebrate by 1956. The labor movement had made historic gains in Detroit during the post-World War II era and it was one of the most heavily unionized cities in the United States.

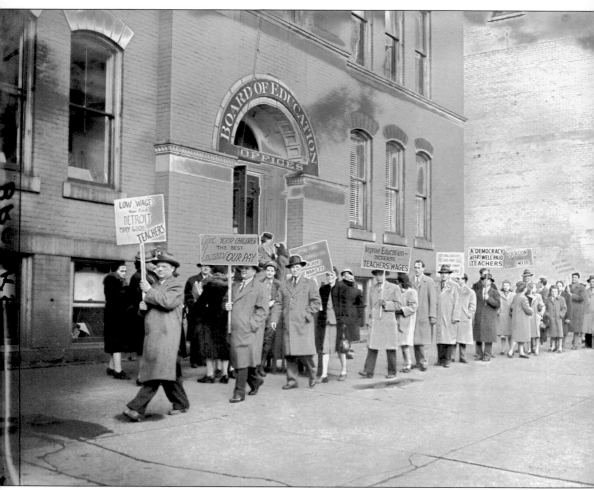

**INFORMATIONAL PICKETING BY DETROIT TEACHERS, 1946.** Picket lines were not exclusive to strikes. In this picture, Detroit teachers are picketing to provide information regarding their low wages. City teachers were members of the Detroit Federation of Teachers, which was established as American Federation of Teachers Local Union 231 in 1931. Although according to Michigan legal code public employees such as teachers were not allowed to strike, DFT members have held walk-outs.

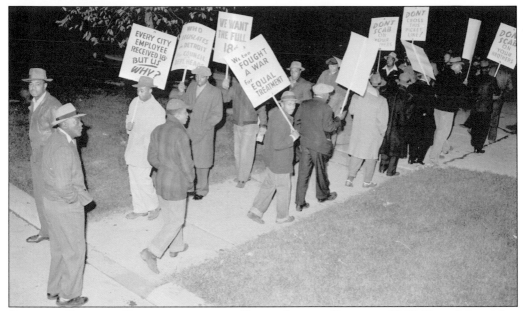

**STRIKING GARBAGE COLLECTORS ON THE PICKET LINE IN DETROIT, 1946.** One of the picket signs in this picture states: "We (African Americans) fought a war for equal treatment." In reality, after the war, black workers were still largely second-class citizens in Detroit. African Americans still faced prejudicial hiring practices, there were still businesses with signs stating "No Coloreds Allowed," and only a few black workers had union offices.

**STRIKING "RED CAPS" AT THE MICHIGAN CENTRAL STATION IN DETROIT, 1946.** These "Red Caps," or railroad station porters, are members of the Brotherhood of Sleeping Car Porters (BSCP) founded by A. Philip Randolph and other black porters in 1925. Randolph, one of the great African-American labor leaders, was BSCP president until 1968. An all-black union, the BSCP faced great opposition from white-led unions when it joined the AFL in 1936.

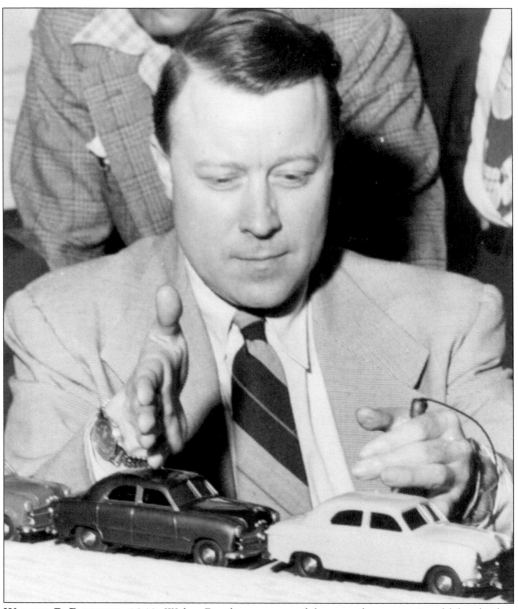

**WALTER P. REUTHER, 1949.** Walter Reuther was one of the most famous national labor leaders from Detroit. Elected UAW president in 1946, Reuther led the union until his tragic death in an airplane crash in 1970. Reuther believed unions were engines of social change, not just a way to increase wages and benefits for members. Under his leadership, UAW members became the elite workers of the industrial world. Benefits such as pensions, health care, and Supplement Unemployment Benefits (SUB) were negotiated in contracts with automotive companies within the confines of a sophisticated corruption-free International union. At the same time as its members received improved working conditions and living standards, the UAW was also providing funds for the civil rights movement and influencing the course of state, local, and national politics. Reuther saw the role of the labor movement in this way: "We are the vanguard in America of the great crusade to build a better world." Perhaps no labor leader in the history of the United States did more to shape modern America.

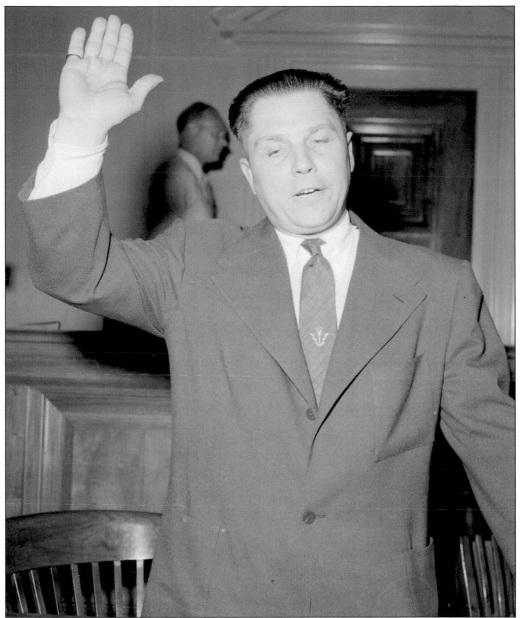

**JAMES R. HOFFA, 1953**. James "Jimmy" Hoffa, president of the International Brotherhood of Teamsters, Chauffeurs, Warehousemen, and Helpers of America from 1957–67, was perhaps the most infamous labor leader from Detroit. Like Reuther, Hoffa also made his bones during the heyday of union organizing in the 1930s. A physically tough labor leader, his first labor action was to lead a 1932 strike of warehousemen at the Kroger Supermarket chain's loading docks in Detroit. By 1957, often through the use of rough tactics, he had helped build the Teamsters into one of the largest and most powerful unions in America. Unlike Reuther, however, Hoffa believed that the primary duty of labor unions was to improve wages and benefits for their members; it was not to lead a social revolution. Moreover, also unlike Reuther, Hoffa was known for his connections to underworld gangs and his corrupt practices. Jimmy Hoffa disappeared from a Detroit restaurant in 1975. He was never seen again and was declared legally dead in 1990.

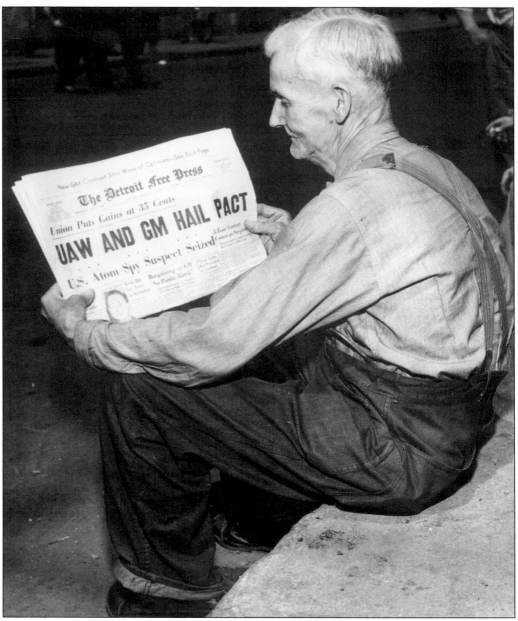

The newspaper headlines read:

New GM Contract Stirs Wave of Optimism—See Back Page

The Detroit Free Press

Union Puts Gains at 35 Cents

**UAW AND GM HAIL PACT**

U.S. Atom Spy Suspect Seized

**BEN MARTIN READING ABOUT THE UAW-GM CONTRACT OF 1950.** This picture shows Ben Martin, a worker at General Motor's Ternstedt Plant in Detroit reading a *Detroit Free Press* headline announcing a contract agreement between the UAW and GM. Martin, a 70-year-old UAW worker with over 27 years of service at the plant, was particularly interested in the results of this historic contract. It featured the first company-funded pension at GM. In this contract, GM was following the precedent set by the UAW-Ford Contract of 1949. Chrysler Corporation provided this benefit after the UAW held a 104-day strike in 1950 under the slogan: "Too Old to Work, Too Young to Die." Prior to these contracts the only retirement funds available to autoworkers were Social Security and individual privately-funded retirement savings accounts. Today, many jobs in many occupations offer company-funded or shared-funding of employee pension plans.

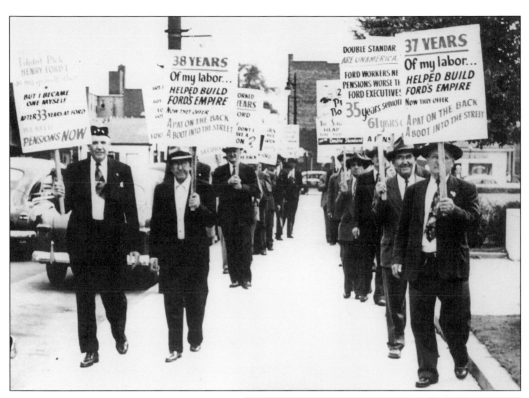

**FORD MOTOR COMPANY RETIREES PICKETING IN SUPPORT OF PENSIONS, 1949.** The inclusion of company-funded pensions was one of the primary goals of union contract negotiations in the post-war era. In this picture, retired UAW members from Ford Motor Company are providing informational picketing during the 1949 contract negotiations. The contract included the first pension plan totally funded by the company and set a precedent for the automotive industry.

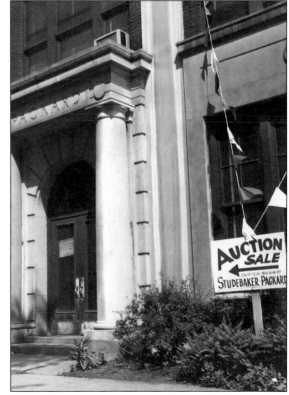

**EXTERIOR OF THE PACKARD MOTOR CAR COMPANY, 1962.** The Packard Motor Car Company moved to South Bend, Indiana, in 1956 after it purchased Studebaker two years earlier. The Hudson Motor Car Company, which began operations in Detroit in 1909, closed its factory in 1954 after it merged with Nash to form the American Motors Corporation. These closings meant a loss of 15,000 jobs in the factories and supporting industries.

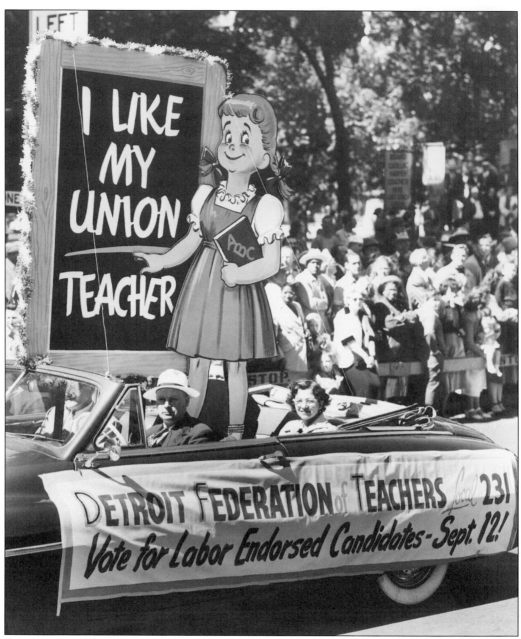

**DETROIT FEDERATION OF TEACHER'S ENTRY IN THE DETROIT LABOR DAY PARADE, 1951.** By the 1950s, Detroit's Labor Day Parade was one of the largest in the nation and an event that local, state, and national politicians, labor leaders, celebrities, and other dignitaries made sure they attended. This picture shows the entry from the Detroit Federation of Teachers Local 231. Organized in 1931, this was one of the first public employee unions in the city. The 1950s and 1960s saw a huge growth in public employee unions which took a more radical role in organizing and securing collective bargaining agreements by challenging state laws. This was a national phenomenon and Detroit was no exception. Thousands of new union members took to the picket lines to voice their concern that teachers, librarians, city workers, and other public employees deserved respect and living wages and other benefits.

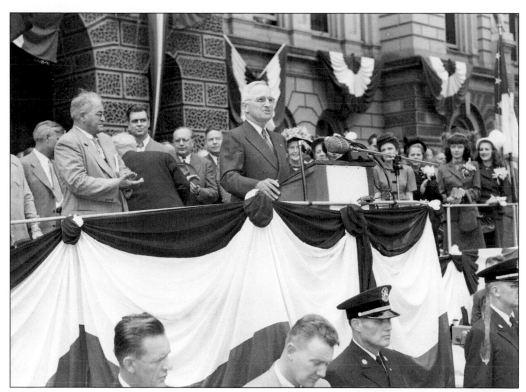

**PRESIDENT HARRY S. TRUMAN SPEAKING AT THE DETROIT LABOR DAY PARADE, 1948.** During the 1950s and 1960s Detroit on Labor Day was often the place to be for presidents of the United States. In this picture in front of the old Detroit City Hall, President Harry Truman addresses the audience after the parade.

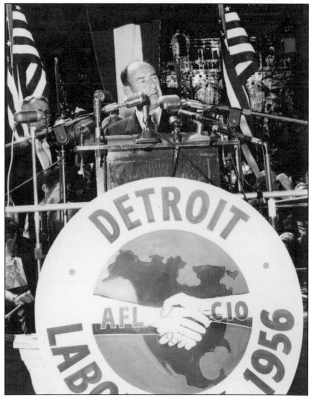

**ADLAI E. STEVENSON SPEAKING AT THE DETROIT LABOR DAY PARADE, 1956.** The Detroit Labor Day Parade was also a prime destination for politicians hoping to raise votes for their election campaigns. In this picture United States presidential candidate Adlai E. Stevenson addresses the Labor Day crowd. Although he had labor's support, he lost the election to incumbent Dwight D. Eisenhower.

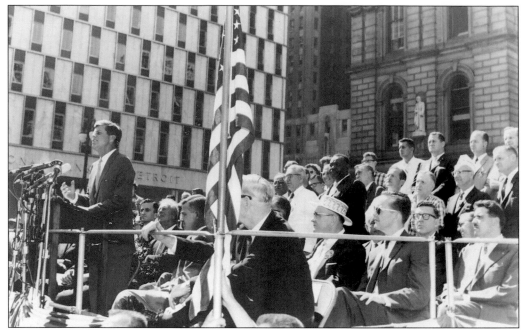

**JOHN F. KENNEDY SPEAKING AT THE DETROIT LABOR DAY PARADE, 1960.** In this picture Untied States presidential candidate John F. Kennedy addresses the Labor Day crowd in downtown Detroit. In this case Kennedy was a successful candidate and Detroit's labor movement mustered crucial votes for a close race between Kennedy and Richard Nixon.

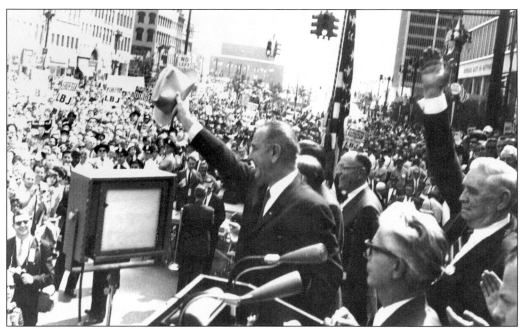

**PRESIDENT LYNDON B. JOHNSON SPEAKING AT THE DETROIT LABOR DAY PARADE, 1964.** In this picture President Lyndon Johnson speaks to the Labor Day crowd during his successful re-election campaign. UAW President Walter Reuther was a close associate of President Johnson and helped develop national urban policy for the Johnson administration.

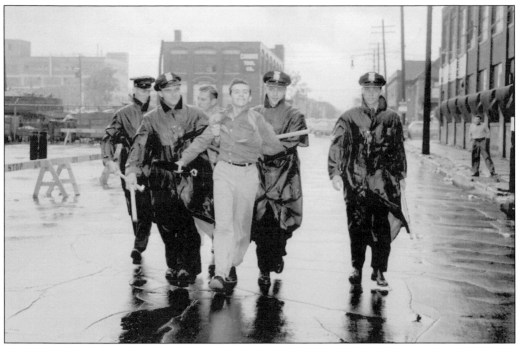

**SQUARE D STRIKE IN DETROIT, 1954.** The United Electrical Workers Union (UE) held an unsuccessful strike at the Square D plant in 1954. During the "Red Scare" of the early 1950s, union activists were often suspected of being communists. Unions such as the UE, whose leaders had communist leanings, were given support from mainstream AFL and CIO unions.

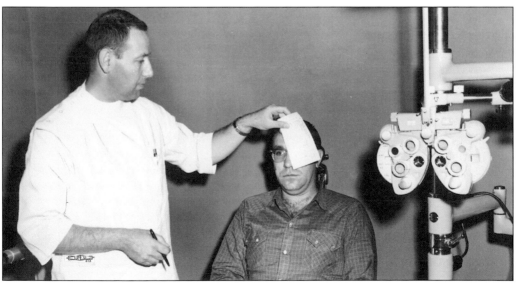

**AN EYE EXAM AT THE UAW HEALTH CARE CLINIC IN DETROIT, 1950S.** One of the primary issues for labor unions in the 1950s and today is health care for their members. During this era many unions established their own clinics to provide health care for their members and still support clinics and health care cooperatives today.

THE FIRST SUB CHECK IS DELIVERED TO UAW MEMBER ANTHONY MAURRINO, 1956. In a historic contract with Ford Motor Company in 1955, the UAW negotiated for SUB (supplemental unemployment benefits) pay. When faced with unexpected lay-offs other than strikes, SUB pay supplemented unemployment compensation, which varied state to state. By the end of 1955, GM, Chrysler, and American Motors included SUB pay in their contracts with the UAW.

DETROIT UNION MEMBER CANVASSING A CITY NEIGHBORHOOD BEFORE AN ELECTION, 1960. As their membership and strength grew in Detroit, many unions became heavily involved in local, state, and national politics. The union member in this picture is calling out the vote for a city election. In a number of local elections from 1945 until today, labor candidates have run for public office.

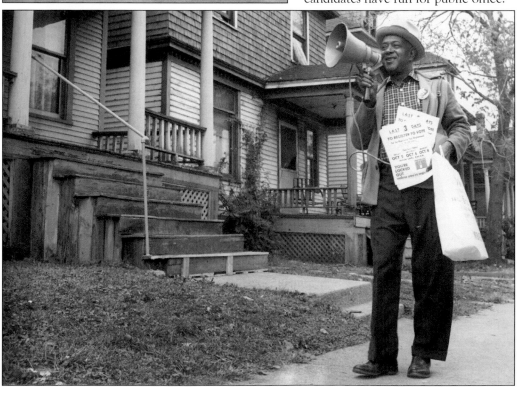

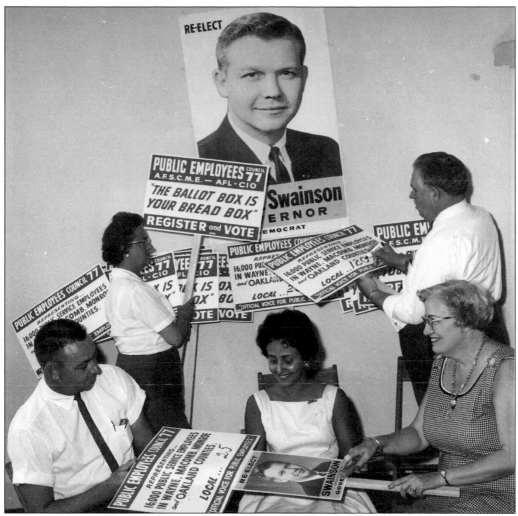

**AMERICAN FEDERATION OF STATE, COUNTY, AND MUNICIPAL EMPLOYEES (AFSCME) MEMBERS WORKING ON THE MICHIGAN GUBERNATORIAL CAMPAIGN, 1962.** In this picture AFSCME members are working on posters and picket signs for Michigan Governor John Swainson's successful re-election campaign in 1962. By this time the labor movement in Michigan, with its center of power in metropolitan Detroit, was allied with the state and national Democratic Parties and could influence, if not dictate, the outcomes of many state and local elections. Indeed, it was said that one could not run for office in Detroit as a Democrat without the endorsement of the UAW and the metropolitan AFL-CIO. One of the most powerful unions in the state and the city was and still is the AFSCME, which has several locals in metropolitan Detroit and represents most city employees. AFSCME was established in 1937 as one of the first public employees unions. The first Detroit local was formed in 1941.

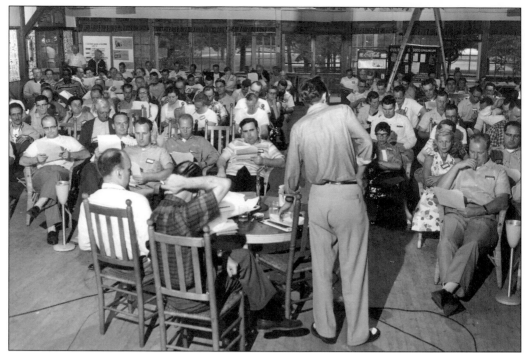

**UAW REGIONAL LEADERSHIP CLASS, 1950S.** This picture shows a 130 member UAW regional leadership training class held at the FDR-CIO Education Center in Port Huron, Michigan, in the 1950s. As unions grew in Detroit, they often added educational departments to their organizations to train union officials and members in administrative and organizational skills. The UAW now has a large education center at Black Lake in northern Michigan.

**DETROIT STREET RAILWAYS BASKETBALL TEAM, 1950S.** These basketball players are members of the Amalgamated Association of Street, Electric Railway, and Motor Coach Employees of America, which was the ancestor of the Amalgamated Association of Street Railway Employees. The union changed its name to the Amalgamated Transit Union in 1965. Like many other unions, over the course of over 75 years the name of the union changed as its work changed.

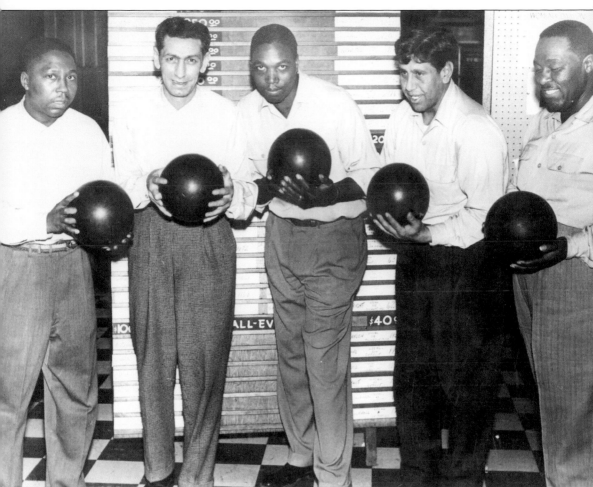

**UAW Bowlers in Detroit, 1955.** This picture shows an integrated bowling team from the 1955 UAW International Bowling Tournament. Although this photograph generally depicts the union's effort to create recreational activities for its members, there is a deeper meaning to the image: it represents the UAW's drive to desegregate itself and eliminate racial prejudice among its members. Although most unions wrote anti-discrimination passages in their constitutions and by-laws, implementing such policies was another thorny issue. Progressive union leaders and members who believed in equality and the goals of the civil rights movement had to overcome long-standing rank-and-file bias held by their members. The UAW decided one of the best methods of breaking down racial barriers among its members was to enforce desegregated sports teams. This strategy was first used when the UAW organized union bowling leagues and it proved to be particularly effective.

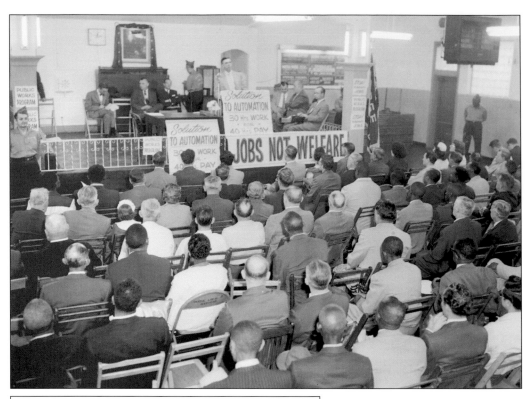

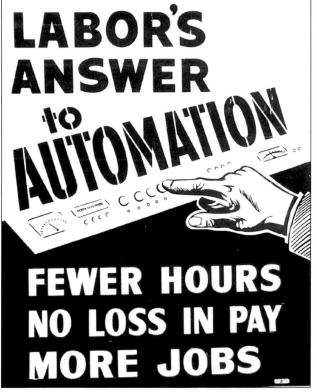

**LABOR'S ANSWER to AUTOMATION**

**FEWER HOURS NO LOSS IN PAY MORE JOBS**

**UNEMPLOYMENT MEETING IN DETROIT, 1956.** As this picture suggests, when working within an economic system that experiences ups-and-downs, especially when that system is tied to the fortunes of the automobile business, unemployment is always a concern for the labor movement. The signs at this unemployment meeting speak to an issue that unions still grapple with—automation that eliminates jobs.

**UAW LABOR POSTER, C. 1960.** This poster created and published by the UAW Education Department speaks to one solution to the problems associated with automation—reduce work hours to create more jobs with no loss in pay. This idea did not catch on with corporate leaders.

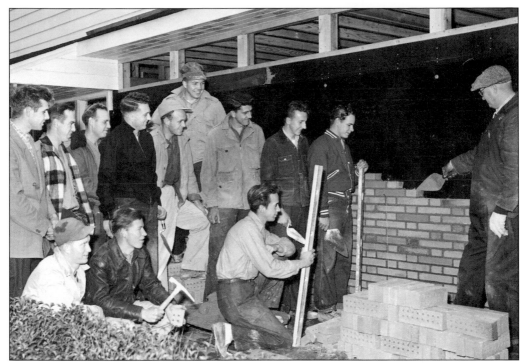

APPRENTICE BRICKLAYERS WATCH A UNION INSTRUCTOR IN DETROIT, C. 1953. These apprentice bricklayers are learning their trade from a union bricklayer and will soon join one of the oldest unions in the United States: the Bricklayers, Masons, and Plasterers' International Union of America. This union traces its origins to the Civil War.

APPRENTICESHIP GRADUATION CLASS OF SHEET METAL WORKERS IN DETROIT, 1953. Craft unions have controlled the training of new members or apprenticeships since the skilled trades were first organized in the United States. This is still an important issue for trade unions today as well as for skilled trades departments in many industrial unions. After the experience of World War II, more and more women and minorities are entering union apprentice programs.

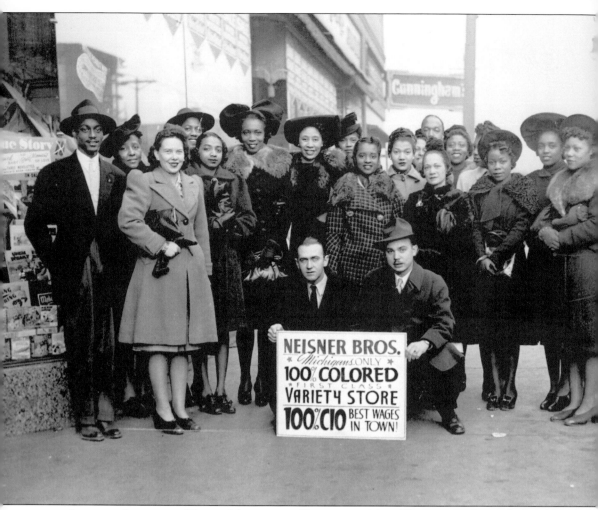

**AFRICAN-AMERICAN UNION MEMBERS IN DETROIT, 1940S.** This picture shows the workforce from a retail store in Detroit's African-American community. During the early years of the labor movement in Detroit until the post-World War II era, black workers were often denied membership or given second-class status in trade unions. In Detroit, there were still stores, restaurants, and other businesses that placed signs in their windows that read "No Colored Allowed." Not all unions placed a high priority on eliminating racial discrimination, but the labor movement increased its support for such policies as the civil rights movement gained momentum during the 1950s. In this respect many CIO unions led the way. Eliminating racial discrimination in the labor movement is still an ongoing process in the 21st century and Detroit's labor movement with its large African-American membership has provided leadership for the cause.

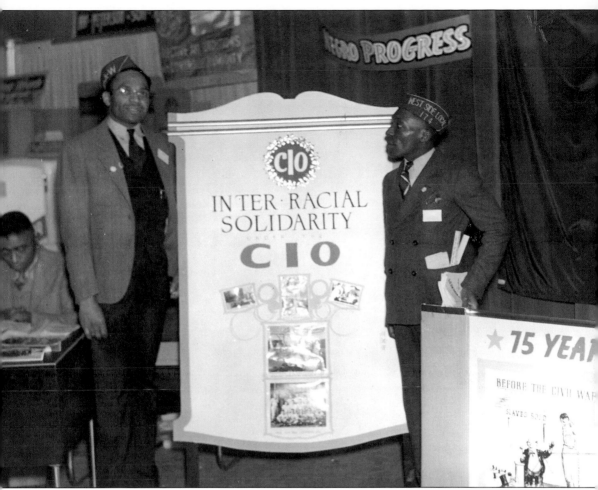

**AFRICAN-AMERICAN UNION MEMBERS IN DETROIT, C. 1950.** The labor movement in Detroit also offered African Americans an opportunity to better their standard of living and a vehicle for increased political power. Some of Detroit's best-known black political statesmen in Detroit such as Coleman Young and Horace Sheffield began their careers as union activists.

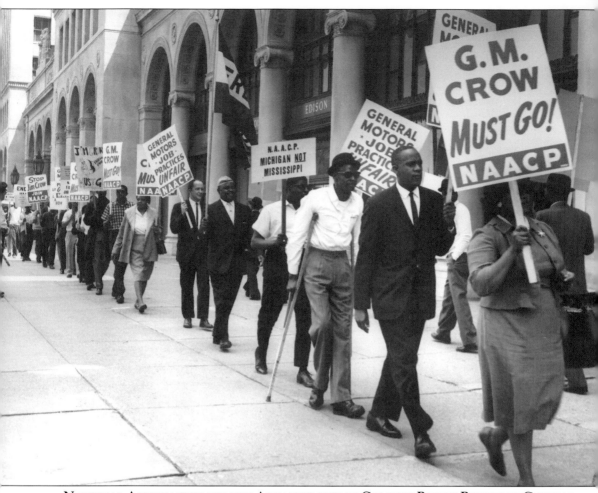

**NATIONAL ASSOCIATION FOR THE ADVANCEMENT OF COLORED PEOPLE PICKETING GENERAL MOTORS HEADQUARTERS IN DETROIT, 1964.** As Detroit entered the decade of the 1960s, the Civil Rights movement was growing rapidly in the city and across America. The achievements of this movement would reshape the nature of Detroit's unions.

## Six

# TOUGH TIMES

# 1960–1990

A SERVICE STATION SIGN IN DETROIT, 1974. Unions had not only survived the 1940s and 1950s, they entered the 1960s as strong, dynamic organizations. In the 1970s and 1980s, however, unforeseen forces such as competition from foreign automakers, gasoline shortages, computers, and robotics changed production processes in the automobile industry and the nature of work in Detroit. Many high-wage union jobs left the city and its population began to decline.

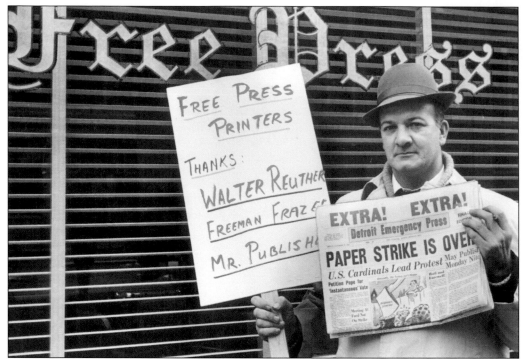

**Tom Kelly, Chair of the Typographical Union at the *Detroit Free Press*, November 1964.** By the 1960s the labor movement was firmly established in Detroit, but there were still struggles. In 1964 the city's oldest union, the International Typographical Union, held a 131-day strike at the *Detroit Free Press*. This picture illustrates the success of the strike and that various Detroit unions lent their support.

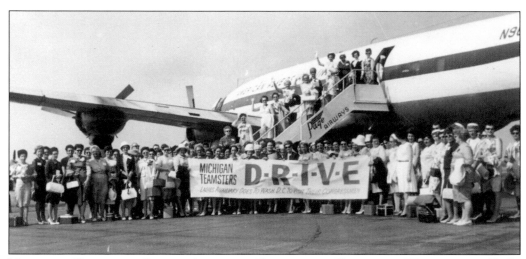

**Michigan Teamsters Ladies Auxiliary Boarding a Plane for Washington D.C., 1968.** As Detroit's unions matured they became more heavily involved in political affairs as a means of supporting their members' best interests and protecting their bargaining gains. The Teamsters launched DRIVE (Democrat, Republican, Independent Voter Education) in 1963. In this picture, the Michigan Teamsters Ladies Auxiliary is going to Washington to visit their congressmen.

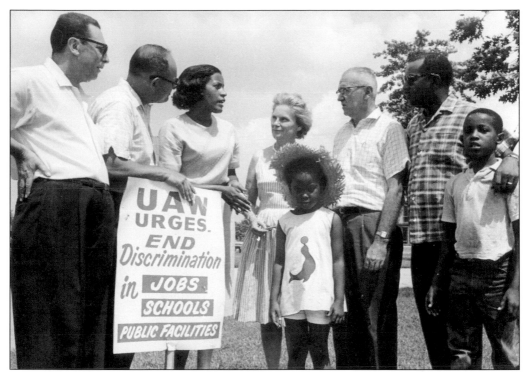

**CIVIL RIGHT MARCHERS IN OAK PARK, MICHIGAN, IN METROPOLITAN DETROIT, 1963.** The Civil Rights movement was well underway in metropolitan Detroit by 1963. This picture shows marchers in the Detroit suburb of Oak Park. The UAW was one union that supported the Civil Rights movement with a great deal of financial and human resources. Millie Jeffrey, head of the UAW's Community Relations Department, is fourth from the left.

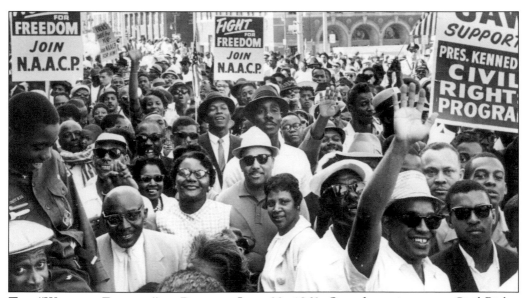

**THE "WALK TO FREEDOM" IN DETROIT, JUNE 23, 1963.** One of most important Civil Rights events in the history of Detroit was the "Walk to Freedom" on June 23, 1963. Pictured here are some of the over 200,000 people who marched down Woodward Avenue in the heart of the city.

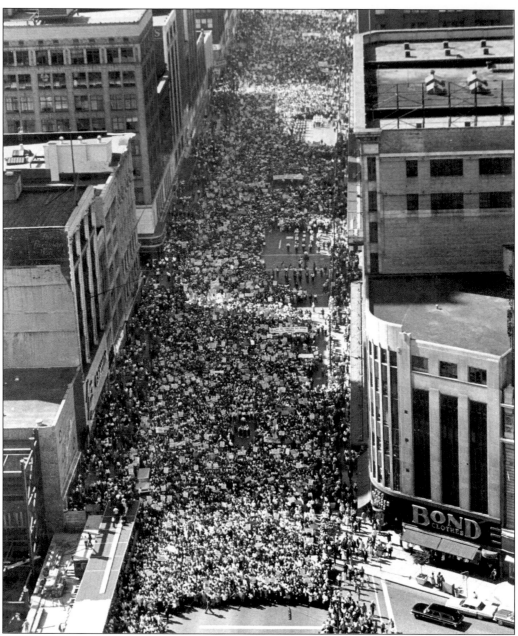

**"WALK TO FREEDOM" ON WOODWARD AVENUE IN DOWNTOWN DETROIT, JUNE 23, 1963.**
This picture shows many of the over 200,000 people who marched in the "Walk to Freedom" in Detroit on June 23, 1963, to protest police violence against Civil Rights demonstrators in Birmingham, Alabama. The featured speaker of the day was the great Civil Rights leader Dr. Martin Luther King, who gave the demonstrators a preview of his famous "I Have a Dream" speech. The rally was unprecedented in size and motive, and it was a historic national event. One month later, King gave his profound address to a massive rally of over 250,000 in Washington D.C. In both cases, the Detroit labor movement supported the rallies; in particular, Walter Reuther and the UAW provided financial, human, and moral support to King as well as the civil rights movement at large.

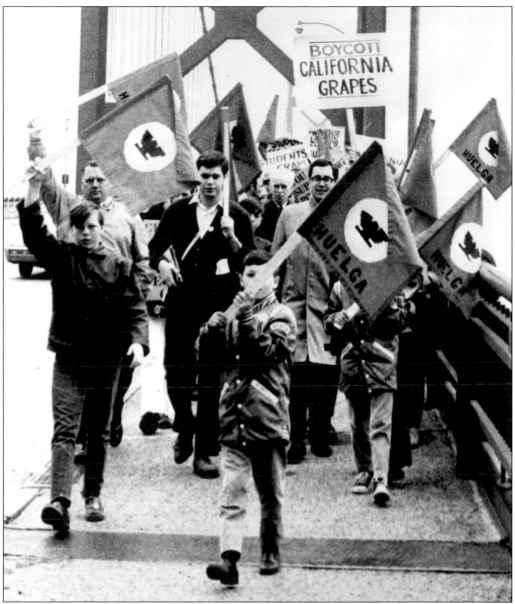

**UNITED FARM WORKER ORGANIZING COMMITTEE SUPPORTERS MARCH ACROSS THE AMBASSADOR BRIDGE IN DETROIT, 1966.** This picture shows a march in support of a grape boycott called by the United Farm Worker Organizing Committee (UFWOC)—the predecessor of the United Farm Workers of American Union. Tracing its origins to the National Farm Workers Association formed by Cesar Chavez in 1962, the UFW has the tough job of organizing migrant farm labor. The "Great Grape Boycott," which asked American consumers to boycott all California table grapes, was called by UFWOC in 1966 and lasted until 1970 when major growers signed a contract. The success of the boycott and awareness of the terrible conditions under which migrant workers labored was due to nation-wide demonstrations, community involvement, and support from labor unions. The UAW was a crucial supporter of UFWOC. Today's UFW is still organizing farm labor in the Southwest United States and fighting against use of pesticides in the fields where they work.

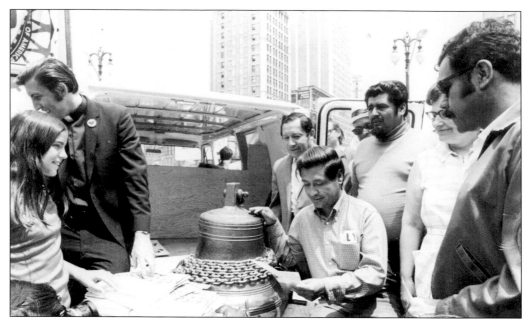

**FREEDOM BELL CEREMONY IN DETROIT, MAY 1970.** This picture shows the Freedom Bell that was given to Cesar Chavez (sitting with bell) by the UAW in 1970. To the far right is Hijinio Rangel, head of UFWOC's Detroit Grape Boycott office. With its large working-class population, Detroit was a stronghold for the grape boycott.

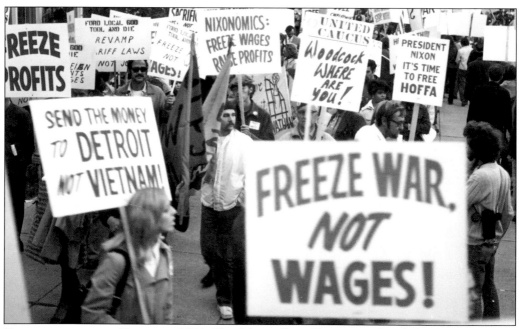

**DEMONSTRATION IN DETROIT, 1971.** This labor rally in Detroit was largely held to protest the Vietnam War, but these union members were also protesting the wage and price policies of United States President Richard Nixon and requesting Jimmy Hoffa's release from prison. Much like American society at large in the 1960s, however, the labor movement was also divided in many ways: for example, many union members supported U.S. policy in Vietnam and voted for Nixon.

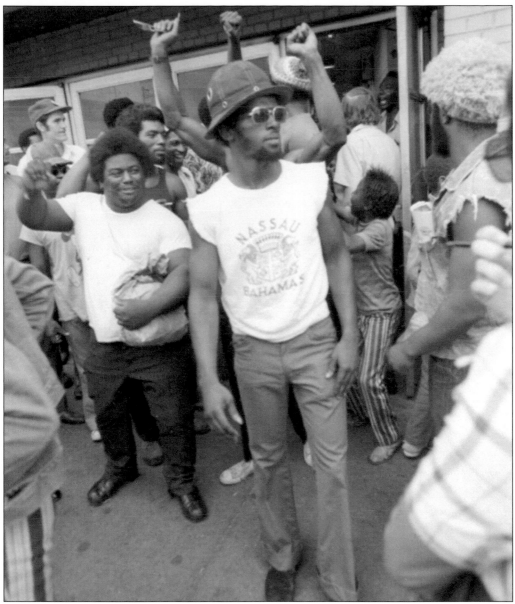

**WILDCAT STRIKERS LEAVING CHRYSLER'S JEFFERSON AVENUE ASSEMBLY PLANT IN DETROIT, 1973.** Throughout American history, there have been wildcat strikes. These are strikes that are held by individuals without the endorsement of a local union or authorization from a parent union. Most wildcat strikes are spontaneous affairs, held without planning or preparation. In some cases wildcat strikes are held by union members to protest the policies and practices of union leadership. In Detroit during the 1960s and 1970s there were a number of wildcat strikes held by militant African-American workers such as those pictured here to protest discrimination in the workplace and within union administration. One of the most famous dissident groups was the Dodge Union Revolutionary Movement (DRUM), a militant black dissident group within UAW Local 3 at the Dodge Main Plant in Hamtramck, Michigan. Although dissident groups are a thorn in the side of union leadership, at times their actions have fostered positive change in the labor movement or at least brought attention to problems in the workplace.

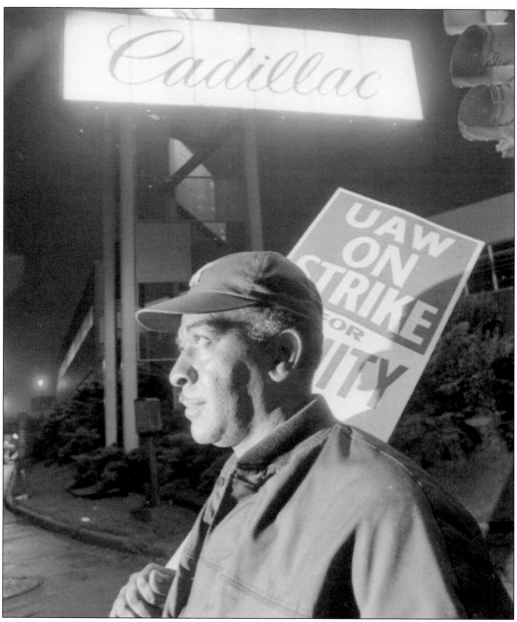

**STRIKER IN FRONT OF CADILLAC'S CLARK STREET ASSEMBLY PLANT IN DETROIT, 1970.** Shortly after gaining the UAW presidency in 1970, Leonard Woodcock led UAW members in a historic strike against General Motors. The UAW had not conducted a strike against GM since 1946 and long-simmering resentments between the company and the union soon became headline news. At the top of the list were the increasing number of UAW local union demands for improvements in health, safety, and other local working conditions. After 67 days GM settled with the UAW and the results were historic. Woodcock's bargaining skills led to a landmark contract that included open-ended cost of living allowances for GM workers and a "30 and out" pension plan that allowed workers to retire after 30 years of service regardless of their physical age. Most important, the contract allowed for greater autonomy for labor actions by union locals. Woodcock had earned the respect of both UAW members and GM executives.

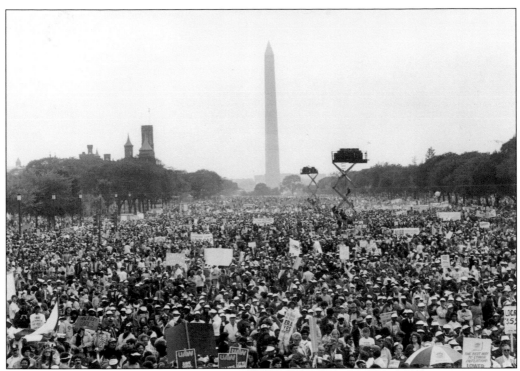

**UNEMPLOYMENT RALLY IN WASHINGTON D.C., 1975.** In 1974 the first major gasoline crisis hit the United States, heavily impacting sales in the automobile industry and therefore Detroit's economy. This prompted massive lay-offs in the automobile industry. This unemployment rally in Washington D.C. was organized by the labor movement and included a large contingent of workers from Detroit. (Courtesy of Barbara Barefield, UAW.)

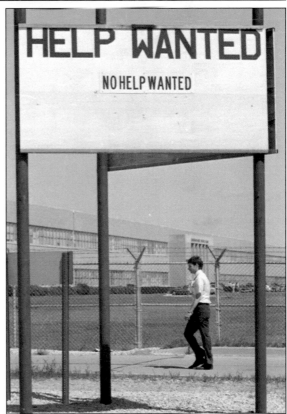

**SIGN IN DETROIT, 1977.** Beginning in the late-1970s Detroit's labor movement began to lose members as the nature of the city's economy changed for the worse. In particular, Detroit's automakers began to lose market share to foreign carmakers, which now produced high-quality, gas-sipping cars. This affected not only autoworkers—many of whom were laid-off permanently—but also union workers in industries and businesses that supplied the automobile industry.

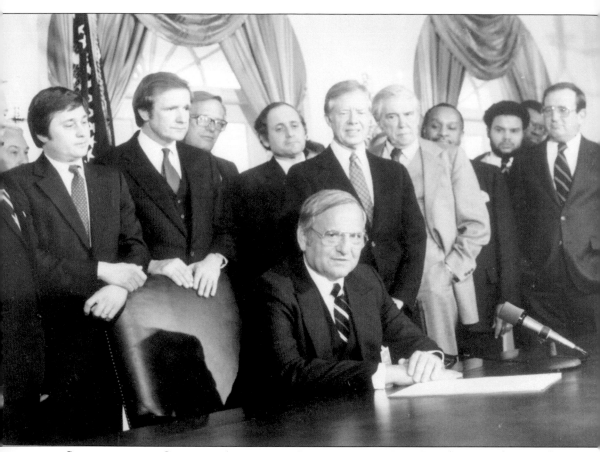

**SIGNING OF THE CHRYSLER AGREEMENT, JANUARY 1980.** In 1979, after several years of poor sales, Chrysler Corporation declared that it was nearly bankrupt. With 200,000 employees, if Chrysler had closed its doors, the effects would have been devastating to Detroit and many other American cities. Through the efforts of U.S. President Jimmy Carter, Michigan Governor James Blanchard, Senator Don Riegle, UAW President Douglas Fraser, and others, an agreement was reached: the federal government endorsed a $4 billion loan to save Chrysler. To do their part to save the company, three times between 1979 and 1981 UAW members granted contract concessions to Chrysler in return for future profit sharing and job security assurances. Pictured here is Chrysler chairman Lee Iaccoca (sitting). Behind him are Jimmy Carter and Doug Fraser. At the far left is Michigan Governor James Blanchard, and to his left is Michigan Senator Don Riegle.

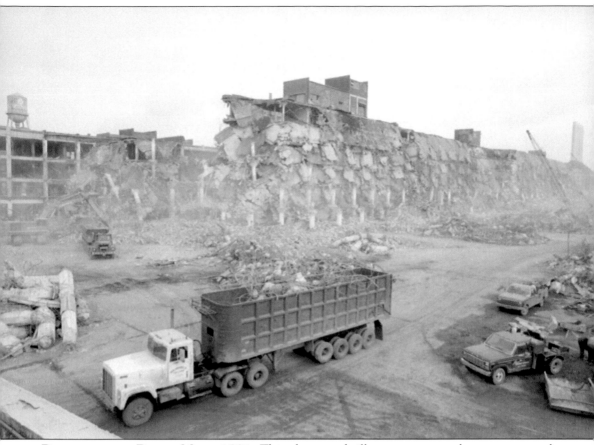

**DEMOLITION OF DODGE MAIN, 1981.** This photograph illustrates a scene that was repeated many times in Detroit and across the nation. Venerable old automobile factories, whether assembly plants or parts manufacturers, were razed or left empty. As computers and robotics revolutionized automobile work, fewer factories and fewer workers were needed to produce cars and parts, and older factories were less adaptable and more costly than building new factories.

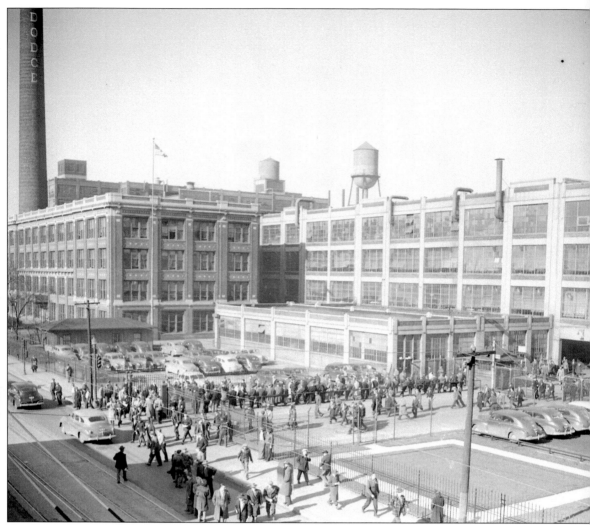

**DODGE MAIN ASSEMBLY PLANT IN HAMTRAMCK, MICHIGAN, 1946.** Pictured here is Chrysler Corporation's Dodge Main assembly plant. This plant opened in 1914 when the Dodge Brothers, important automobile suppliers, began to make cars under their own name. By 1980 it had one of the most diverse workforces in the city. It was, however, one of the oldest automobile factories in America and its multiple-story building was no longer adaptable for modern production.

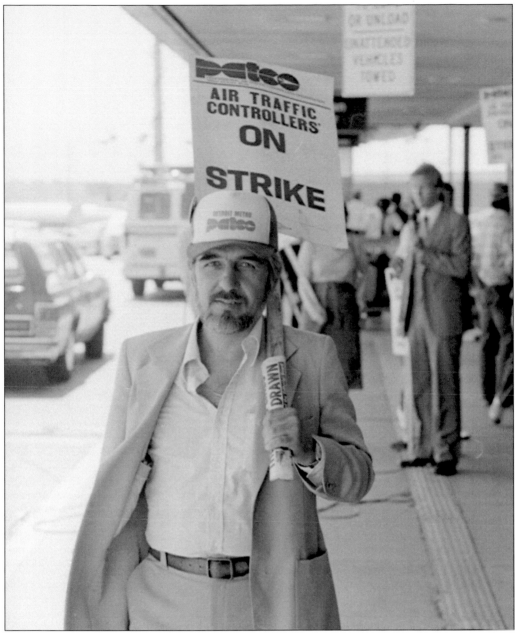

**STRIKING AIR TRAFFIC CONTROLLER PICKETING AT METROPOLITAN AIRPORT IN DETROIT, 1982.** Times were tough for the labor movement in the late-1970s and early-1980s. When Ronald Reagan became president of the United States, the national political mood shifted to the conservative side. The Professional Air Traffic Controllers Organization (PATCO) made an ill-fated decision to hold a strike in 1982. Over two-thirds of the 17,400 PATCO members walked off the job, which signaled the end of their union. Taking a "get-tough" stance, President Reagan fired the striking workers, thereby busting the union. This set a dangerous precedent and soon the labor movement was on the defensive and unions devoted their attention to retaining a measure of power in the face of declining membership, an increasingly hostile federal government, and an often disinterested public.

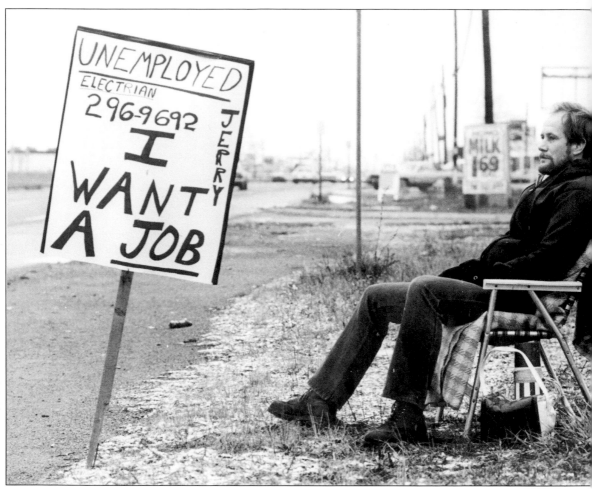

**UNEMPLOYED WORKER IN DETROIT, 1976**. Compare this picture to the one on page 41. Although unemployment in the 1970s and 1980s was not as bad as the Great Depression of the 1930s, it reached double-digit levels in many older industrial cities as well as other areas of the United States. Journalists and other observers began to refer to Detroit, Cleveland, Milwaukee, and other older Midwestern industrial urban areas as "Rust Belt" cities. The national economy was changing from one based upon heavy industry and manufacturing to one that relied upon computers, information, and services. This shift in industry had devastating effects upon the labor movement in Detroit. As automobile factories closed and other older unionized businesses reduced their workforces, union membership plummeted. Many metropolitan Detroiters moved away to find jobs in other states. Some, such as the worker pictured here, did what they could to find work. (Courtesy of Joe Crachiola, *Macomb Daily News*.)

*Seven*

# LABOR AT THE
# TURN OF THE CENTURY

## 1990–2000

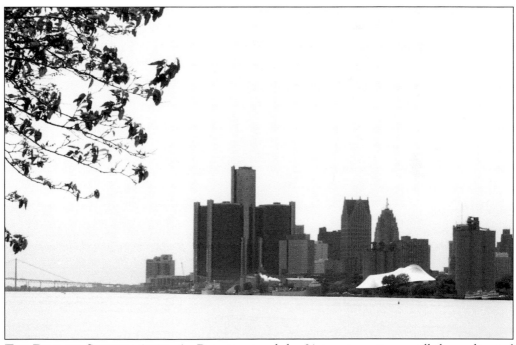

**THE DETROIT SKYLINE, 2001.** As Detroit entered the 21st century, it was still the undisputed Motor City. Although it no longer produces half the world's cars, it is still the technical and intellectual center of the global automotive industry. As jobs shift from manufacturing to service and high-tech industries, the labor movement is attempting to adjust to the times.

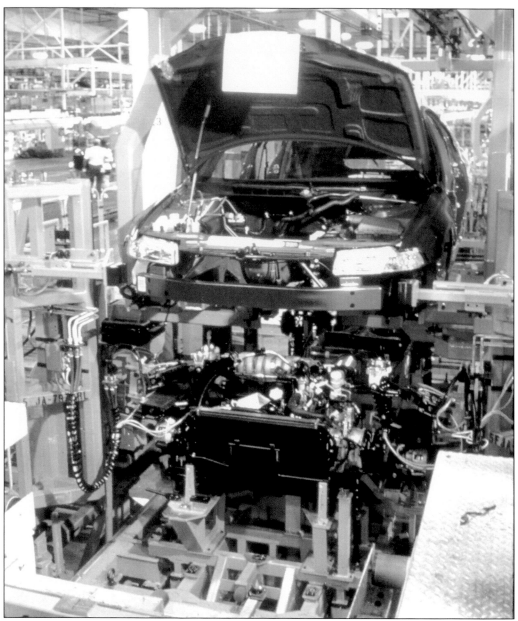

**A MODERN AUTOMOTIVE ASSEMBLY LINE OPERATION IN DETROIT, 1995.** This photograph from the General Motors Detroit-Hamtramck Assembly Plant illustrates the tremendous transformation that occurred in the automobile manufacturing process. Few workers are seen on many parts of the assembly line where they have been replaced by computer-controlled machines and robots. Locally in Detroit this factory is known as the "Poletown" plant, which refers to its location on the Hamtramck-Detroit border and the historical Polish immigrant neighborhood that was razed to create space for it. The plant was also originally conceived as a "Lights Out" factory; that is, a production facility which utilized robots and computers and needed few humans. It was an idea before its time and human workers are still necessary for automobile manufacturing. Today, the plant employs over 2,000 UAW members in high-wage jobs that are essential to the well-being of Detroit's economy.

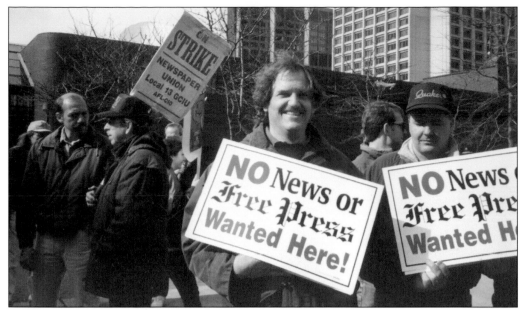

**STRIKING *DETROIT NEWS* AND *DETROIT FREE PRESS* WORKERS, 1996.** On July 13, 1995, what is believed to be the longest strike in Detroit history began when about 2,500 workers from the *Detroit News* and *Detroit Free Press* walked off the job after contract negotiations broke down. Six unions were involved in the strike: the Teamsters, the Newspaper Guild, the International Typographical Union, and locals of the Graphic Communications International Union. (Courtesy of Verna Kemp.)

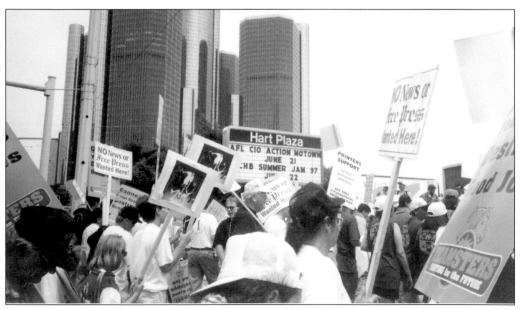

**"ACTION MOTOWN" RALLY IN DETROIT, JUNE 1997.** Pictured here is a rally sponsored by AFL-CIO and held in downtown Detroit in 1997 to support the striking newspaper workers. Over 40,000 supporters and union members from Canada, Michigan, and other states came to Detroit for the rally and to show their support for the newspaper boycott called by the striking unions. (Courtesy of Verna Kemp.)

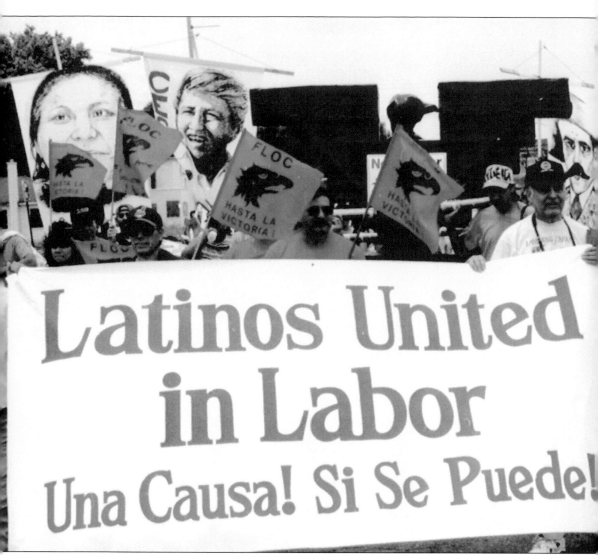

**LATINO SUPPORTERS OF STRIKING NEWSPAPERS WORKERS AT THE "ACTION MOTOWN" RALLY IN DETROIT, JUNE 1997.** Beyond the rally pictured here, the newspaper strike featured bitter picket line confrontations: acrimonious exchanges between newspaper management who hired replacement workers (commonly known as "scabs") and striking workers, and the filing of unfair labor practices charges against the newspapers by the striking unions. The unions legally ended the Detroit newspaper strike in the 1997, but three more years passed before court cases regarding unfair labor practices by the newspaper parent companies, Gannett Company Inc. and Knight-Ridder Inc., were finally concluded when the U.S. Court of Appeals ruled in favor of the newspapers. By this time most of the 2,500 striking workers had moved on the other jobs, and the newspapers had lost one-third of their sales.

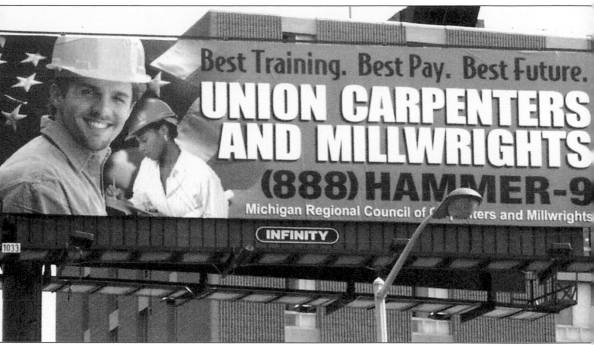

**BILLBOARD IN DETROIT, 2001.** Despite the drastic loss of union membership and such struggles as the newspaper strike, the labor movement still has a measure of power in the Motor City. There has been growth for such unions as the Service Employees International Union, which, as the name suggests, organizes nurses, health care providers, hotel workers, janitors, and other workers in the service industry. Indeed, the fastest growing unions in Detroit and the United States are those that organize workers in the service industry. With the construction of two new sports stadiums and new office buildings in metropolitan Detroit, unions that represent carpenters, millwrights, electricians, and other trades people are also strong. In this respect, as the sign pictured here suggests, another important area of strength for the unions is their control over apprenticeship programs in the skilled trades.

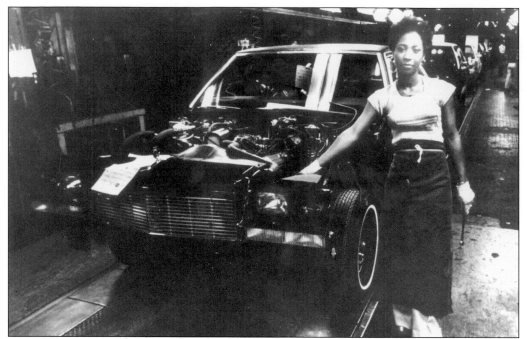

**AFRICAN-AMERICAN AUTOWORKER IN DETROIT'S CLARK STREET CADILLAC ASSEMBLY PLANT, 1977.** Although this photograph is from 1977, it illustrates the changing nature of Detroit's workforce—in particular its automobile industry workforce—over the last century. In Detroit, in many industries and businesses African Americans form a large percentage of the metropolitan union workforce

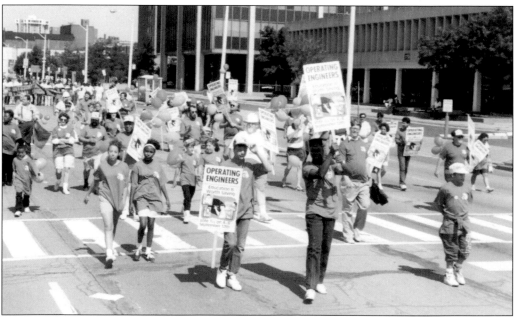

**THE DETROIT LABOR DAY PARADE, 1993.** The Labor Day Parade is still held every year on Woodward Avenue in downtown Detroit, and thousands still march in the parade. This Labor Day tradition is now over one hundred years old. (Courtesy of Maria Catalfio.)

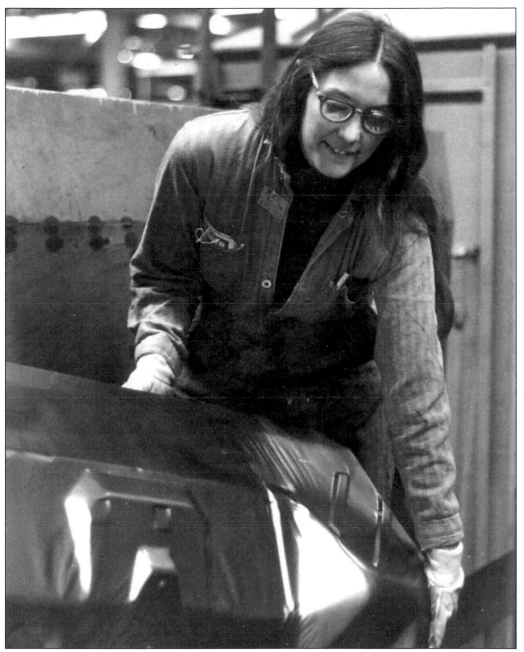

**UAW Member Lana Boldi on the Assembly Line at the Fisher Body Plant in Kalamazoo, Michigan, 1974.** By the end of the 20th century women represented a large percentage of the metropolitan Detroit workforce. Over the course of the last one hundred years, women have moved from limited job opportunities in such traditional roles as domestic work, sewing, teaching, and nursing, into nearly every occupation in the city. Pictured here is Lana Boldi, 33-year-old apprentice in welding equipment maintenance and repair at the General Motors Fisher Body plant in Kalamazoo, Michigan. A member of UAW Local 488, she was the first female apprentice in the UAW. Women such as Boldi led the way for women in skilled trades in the 21st century.

**A YOUNG DETROITER, 1997**. For over 150 years, whether small or large, weak or strong, the labor movement has helped shape the modern city. What will the future be for this young member of a union family? (Courtesy of Verna Kemp.)